Magic Lantern Guides

SONY®

DSLR

α 100

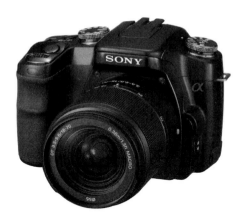

Peter K. Burian

LARK BOOKS
A Division of Sterling Publishing Co., Inc.
New York

Book Design and Layout: Michael Robertson
Cover Design: Thom Gaines
Associate Art Director: Lance Wille

Library of Congress Cataloging-in-Publication Data

Burian, Peter K.
 Sony DSLR A100 / Peter K. Burian.
 p. cm. -- (Magic lantern guides)
 Includes index.
 ISBN 1-60059-082-9 (pbk.)
 1. Sony cameras. 2. Photography--Digital techniques. I. Title.
 TR263.S66B87 2007b
 771.3'3--dc22

 2006029189

10 9 8 7 6 5 4 3 2

Published by Lark Books, A Division of
Sterling Publishing Co., Inc.
387 Park Avenue South, New York, N.Y. 10016

Distributed in Canada by Sterling Publishing,
c/o Canadian Manda Group, 165 Dufferin Street
Toronto, Ontario, Canada M6K 3H6

Distributed in the United Kingdom by GMC Distribution Services,
Castle Place, 166 High Street, Lewes, East Sussex, England BN7 1XU

Distributed in Australia by Capricorn Link (Australia) Pty Ltd.,
P.O. Box 704, Windsor, NSW 2756 Australia

If you have questions or comments about this book, please contact:
Lark Books
67 Broadway
Asheville, NC 28801
(828) 253-0467

Printed in United States

ISBN 13: 978-1-60059-082-5
ISBN 10: 1-60059-082-9

For information about custom editions, special sales, premium and corporate purchases, please
contact Sterling Special Sales Department at 800-805-5489 or specialsales@sterlingpub.com.

Contents

Understanding Digital Photography 13
The Sony-Konica Minolta Connection 13
Differences Between Digital and Film Photography 14
The Digital Sensor vs. Film ... 15
 Memory Cards vs. Film ... 16
 The LCD Monitor .. 18
 Exposure and the Histogram 19
 ISO (Sensitivity) ... 20
 Noise/Grain .. 20
 File Formats .. 21
 Resolution .. 21
 White Balance .. 22
 Cost of Shooting ... 23

Features and Functions .. 25
Overview of Features ... 31
Specifications ... 32
Camera Activation ... 34
 Power Switch .. 34
 Power Save .. 34
 External Ports ... 34
 Resetting Controls .. 35
Camera Controls ... 36
 The Mode Dial .. 36
 Controller .. 36
 Function Dial and Function (Fn) Button 37
Power Sources .. 38
The Viewfinder .. 40
The LCD Monitor ... 41
 Data Display ... 41
 Playback Options .. 43
 Deleting Images .. 45
 Protect Images from Deletion 45
The CCD Imaging Sensor ... 46

The Sensor and Effective Focal Lengths 47
Cleaning the CCD Sensor ... 48
How to Remove the Memory Card 49
Camera Care and Cleaning ... 49

Digital Recording and In-Camera Processing 53
File Formats ... 53
Image Size (Resolution) .. 54
Quality (Compression) .. 56
ARW Format RAW Files ... 57
RAW & JPEG Recording .. 58
Approximate File Sizes ... 59
Memory Card Capacity ... 60
RAW vs. JPEG .. 60
White Balance .. 61
White Balance—How It Works 62
Auto White Balance .. 64
Preset White Balance Selections 64
Custom White Balance .. 66
Color Temperature .. 67
White Balance Bracketing 68
Color Spaces and Modes .. 69
Optimizing Images In-Camera (DEC) 72
Contrast .. 73
Color Saturation ... 73
Sharpness .. 74
D-Range Optimizer (DRO) .. 74
Noise Reduction ... 76

The Menus .. 79
The Recording Menus .. 80
Recording Menu 1 .. 80
Recording Menu 2 .. 82
Autoflash vs. Fill-Flash .. 84
The Playback Menus .. 86
Playback Menu 1 ... 86
Playback Menu 2 ... 88
The Custom Menus .. 90
Custom Menu 1 ... 90
Custom Menu 2 ... 93

The Setup Menus ... 95
 Setup Menu 1 ... 95
 Setup Menu 2 ... 97
 Setup Menu 3 ... 98

Camera and Shooting Operations 103
Image Sharpness ... 103
 Handholding Techniques ... 104
 The Super SteadyShot (SSS) System 104
 SSS in Use .. 106
The Focusing System .. 107
 AF Modes ... 108
 AF Area .. 110
 Manual Focus .. 113
Drive Modes .. 113
 Single-frame adv. .. 113
 Continuous adv. .. 114
 10s self-timer ... 114
 2s self-timer ... 114
Exposure .. 115
 The Role of Shutter Speed and Aperture 116
 Equivalent Exposure .. 117
 Measuring Brightness .. 117
 ISO ... 118
Exposure Modes ... 120
 Auto Mode (AUTO) .. 120
 Scene Selection Modes .. 120
 Program (P) .. 122
 Aperture Priority (A) .. 123
 Depth of Field—A Short Course 123
 Shutter Priority (S) .. 126
 Exposure Control Range Warnings 129
 Manual (M) ... 130
 Bulb Exposure .. 131
Metering Method .. 132
 MultiSegment Metering .. 132
 Spot Metering ... 133
 Center Weighted Metering 135
Exposure Compensation ... 135
D-Range Optimizer ... 136

Exposure Bracketing .. 136
Autoexposure Lock (AEL) ... 139
Exposure Evaluation ... 139
 Luminance Limit Warning 140
 The Histogram ... 142

Flash Photography ... 149
The Inverse Square Law ... 149
Guide numbers ... 150
Flash Synchronization ... 150
The Built-in Flash .. 150
 Flash Range .. 151
Accessory Flash Units ... 153
Flash Compatibility .. 153
 Sony Flash Units .. 154
 Sony Flash HVL-F56AM .. 154
 Sony Flash HVL-F36AM .. 154
Macro Flash Units ... 154
Flash Metering Options ... 155
 ADI Flash (Advanced Distance Integration) 156
 Pre-Flash ... 156
Flash Photography and Camera Exposure Modes 157
 AUTO and Scene Modes 157
 Program (P) .. 158
 Aperture Priority (A) ... 158
 Shutter Priority (S) ... 159
 Manual (M) .. 160
Other Flash Options ... 161
 Red-Eye Reduction ... 161
 Rear Sync (REAR) ... 162
 Motion Blur—How It Works 162
 Slow Sync .. 163
Wireless/Remote Flash .. 163
 Wireless/Remote Flash Techniques 164
Modifying Flash Intensity ... 165
 Flash Exposure Compensation 165
 Using Flash with Exposure Compensation 165
High Speed Flash Sync .. 166
Bounce Flash .. 168

Lenses and Accessories ... 171
Effective Focal Lengths .. 172
Selecting a Lens .. 172
Normal Lenses .. 174
Telephoto Lenses ... 174
 Moderate Telephoto Lenses 176
 Longer Telephoto Lenses ... 176
Wide-Angle Lenses ... 177
Understanding the Fine Points of Lenses 178
 Large vs. Small Maximum Apertures 178
 Zoom Lens Pros and Cons 179
 High Tech Glass .. 180
 Ultrasonic Focusing Motor 181
 ADI Compatibility .. 181
 Digital Optimization ... 182
 Close-Up Photography ... 182
Close-Up Accessories .. 183
 Magnifying Filters...183
 Extension Tubes .. 184
Other Lens Accessories ... 185
 Teleconverters ... 185
 Protective Filters ... 186
 Graduated Filters .. 186
 Polarizing Filters .. 186
 Lens Hood .. 187
Camera Support Accessories .. 187

Working with Images .. 191
Image Data ... 191
Downloading Images .. 192
 Memory Card Reader .. 192
 PC Card Adapter ... 192
 Direct from the Camera .. 193
Picture Motion Browser ... 195
Converting RAW/ARW Files .. 196
Other Browser Programs .. 198
Enhancing Your Images ... 199
Image Cataloging .. 200
Image Storage .. 201
Video Output ... 202

Direct Printing .. 203
Digital Print Order Format (DPOF) 204
Digital Prints ... 204
 Computer Download .. 204
 Direct-Print Printers ... 204
 Kiosks ... 205
 Photofinishers and Mini-Labs 205
 On-Line Services .. 205

Troubleshooting Guide .. 207
Web Support ... 207

Glossary ... 212

Index .. 220

Understanding
Digital Photography

The Sony-Konica Minolta Connection

In July 2005 Konica Minolta and Sony issued a press release indicating an agreement to jointly develop digital SLR cameras using technology to be provided by both companies. Then, in January 2006, Konica Minolta announced that it would withdraw from the photo products market and transfer some of its assets to Sony.

By mid 2006, Sony announced the α100 as its first entry into the digital single lens reflex (D-SLR) camera market. This model is the world's first 10-megapixel (MP) model in the entry-level D-SLR category. It is a collaboration between Konica Minolta and Sony and offers the best of both worlds: the most valuable features developed for the Maxxum/Dynax D-SLRs plus sophisticated Sony technology, as well as some new amenities.

The α100 is compatible with all Sony accessories and lenses (including the Carl Zeiss Alpha series). You will also find you can use most Maxxum/Dynax lenses and accessories. For those familiar with Konica-Minolta's Anti-Shake system, the α100 body includes an improved compensating system for camera shake now called Super SteadyShot (SSS). And Sony has introduced a new method to prevent dust from accumulating on the sensor of this camera.

Digital photography offers many advantages over film photography. These include reusable memory cards and the opportunity to immediately see the picture and correct any problems by reshooting while still at the scene.

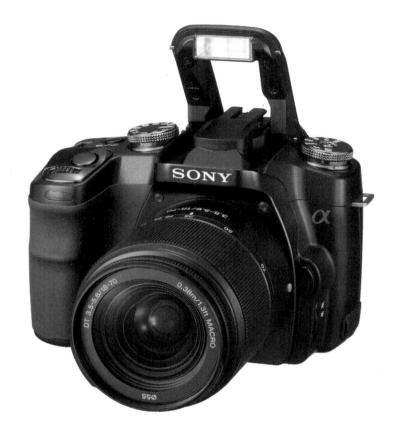

The Sony D-SLR ∝100 is a versatile, easy-to-use, high-resolution camera that offers many options for making great photos. Photo courtesy of Sony Corporation.

Differences Between Digital and Film Photography

Not very long ago it was easy to tell the difference between photos taken with a digital camera and those shot with a traditional film camera: Pictures from digital cameras didn't have the same quality as those from film. However, this is no longer true. With the α100, you can make 13x19-inch (33 x 48 cm) prints that look as good, or better,

than an enlargement from a 35mm negative. When made from your technically best images, even larger prints can be suitable for framing.

Whether digital or film-based, a camera is basically a light-tight box that holds a lens to focus the image. You regulate the amount of light entering this box to strike the light-sensitive medium (film or sensor) by adjusting the f/stop or the shutter speed. However, in traditional photography the image is recorded on film and later developed with chemicals, while in digital photography the camera converts the light to an electronic image. A digital camera immediately processes this image internally and stores it temporarily on a memory card for downloading, while a film camera stores the exposed film for processing at a later time. While many exposure techniques remain the same, digital photography will help you take advantage of a number of enjoyable and creative possibilities available with this new technology.

The Digital Sensor vs. Film
Both film and digital cameras expose pictures in nearly identical fashion. The light measuring (metering) methods are the same, both work with ISO-based systems, and the shutter and aperture mechanisms controlling the amount of light admitted into the camera are the same. These similarities exist because both film and digital cameras share the same goal: to deliver the appropriate amount of light required by the film or sensor to create a good picture.

Not surprisingly, however, digital sensors respond differently to light than film does. From dark areas (such as navy blue blazers, asphalt, and shadows) to mid-tones (blue sky and green grass) to bright areas (such as white houses and sand beaches), a digital sensor responds to the full range of light equally, or linearly. Film, however, responds linearly only to mid-tones (those blue skies and green fairways). Therefore, negative film blends tones very well in highlight areas and slide film blends tones well in shadow areas, whereas digital sensors often cut out the bright tones. Digital responds to highlights like slide film and to shadows like negative film.

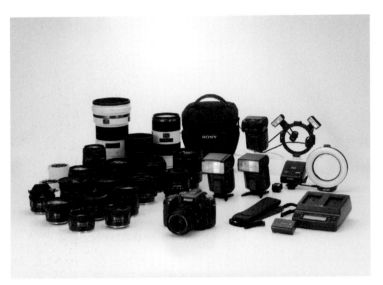

Sony offers a complete selection of lenses, flash units, and other accessories for the ⍺100. Photo courtesy of Sony Corporation.

Memory Cards vs. Film

Memory cards are necessary to store images captured by a digital camera. These removable, reusable cards offer several advantages over film:

More Photos/More ISOs: Standard 35mm film cassettes are available in either 24 or 36 exposures. Memory cards come in a wide range of capacities, and all but the smallest are capable of holding more exposures than a roll of film (depending on the selected file size). Also, a single card can record different ISO settings on a picture-by-picture basis—much simpler than switching rolls of film.

Reusable: Once you make an exposure with film, the emulsion layer is permanently changed and thus, the film cannot be reused. With a memory card, you can erase photos at any time, removing the ones you don't want, creating space for additional photos. This simplifies the process of dealing with

The ability to adjust the camera's sensitivity to light by changing the ISO at any time is an advantageous feature of digital cameras. It is especially useful with rapidly changing light, or when you plan to shoot both indoors and out during an event.

and organizing your final set of images. Once images are transferred to your computer (or other storage medium, such as a CD or DVD), images can be erased or the card can be reformatted and reused.

Durability: Memory cards are much more durable than film. They can be removed from the camera in virtually any conditions without the risk of ruined pictures. They are less susceptible to heat damage and can even be taken through the airport carry-on x-ray inspection machines without suffering damage. (However, the cards are susceptible to magnetic fields so keep them away from stereo speakers and other devices containing powerful magnets.)

Small Size: In the space taken up by just a couple of rolls of film, you can store or tote multiple memory cards that will hold hundreds of images.

Greater Image Permanence: The latent image (exposed but undeveloped film) is susceptible to degradation from atmospheric conditions such as heat and humidity. And new security monitors for packed and carry-on luggage can also damage film. Traveling photographers find that digital photography allows them much more peace of mind. Not only are memory cards more durable, but their images can also be easily downloaded into storage devices or laptops. No more concerns over what to do with precious exposed film!

In addition to providing shooting data, the LCD monitor offers the ability to review and edit photos immediately after they are taken. Photo courtesy of Sony Corporation.

The LCD Monitor

In conventional photography, you are never really sure your picture is a success until the film is developed. You must wait to find out if the exposure was correct or if something happened to spoil the results, such as the blurring of a moving subject or unwanted stray reflections from an on-camera flash.

When using a digital SLR, however, you can see an image on the LCD monitor almost immediately after taking a picture. Admittedly, you cannot see all the details that you would see in a print, but this ability means that you can evaluate the picture you have just shot. If the exposure, lighting, or composition is not quite right, simply re-shoot on the spot. This feature is especially useful in flash photography. In addition to confirming correct exposure, the LCD monitor allows you to check for any excessively bright highlight areas or dark backgrounds, as well as allowing you to evaluate other factors, such as the effect produced by multiple flash units and/or reflectors.

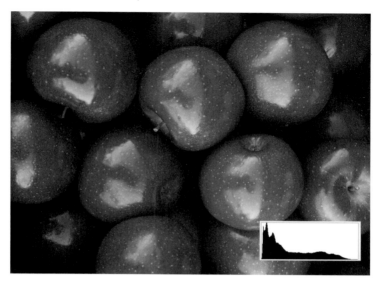

A histogram depicts the distribution of tones from black (left edge of graph) to white (right edge of graph). This histogram is weighted toward dark tones because it corresponds to a low key photo of red apples in shadow with only a small amount of highlight. © Kevin Kopp

Exposure and the Histogram

Digital cameras do not offer magic tricks that let you beat the laws of physics, so incorrect exposure will still cause problems. Too little light makes dark images; too much light makes overly bright images. Granted, you can correct digital images to a certain extent afterwards by using software in a computer, but programs can't add blown details to overexposed images. Getting the correct exposure in-camera can save you a great deal of post processing work.

After you shoot a digital image, a quick glance at the LCD monitor will indicate whether the exposure (image brightness) is close to accurate. Better yet, you can also access two features found in digital photography that give a more scientific evaluation of brightness values: the histogram scale and the highlight/shadow warning, which in the α100

is called a Luminance Limit Warning (see page 140 for details). Because you are able to check exposure using these tools, there is less need to bracket (shoot a series of images at different exposure levels) when using the α100 than with a traditional film camera.

ISO (Sensitivity)

Digital sensors don't have a true ISO. However, their sensitivity has been adjusted electronically to mimic film ISOs. Hence, you can set the ISO to 100 for average daylight shooting, 800 for faster shutter speeds or smaller apertures in less bright situations, or 1600 for low light photography. With a digital camera, you can change ISO from picture to picture, without changing memory cards. It's like changing film at the touch of a button! This provides certain benefits, such as the ability to first shoot indoors without flash at ISO 800, then follow your subject outside into bright sun and optimize image quality by switching immediately to ISO 100.

Noise/Grain

Grain in film appears as an irregular, sand-like texture that, if large, can be unsightly and, if small, is essentially invisible. (A textured look is sometimes desirable for certain creative effects.) It occurs due to the chemical structure of the light sensitive materials and is most prominent in fast films, such as ISO 1600.

The equivalent in digital photography is known as noise, which often occurs as colored specks most visible in dark or evenly colored mid-tone areas. Digital noise occurs for several reasons: sensor noise (caused by heat from the electronics and optics), digital artifacts (when digital technology cannot deal with fine tonalities such as sky gradations), and JPEG artifacts (caused by image compression). Sensor noise is the most common.

Although the α100 includes automatically applied noise reduction processing, digital noise is most prominent in images made at high ISO settings (especially at ISO 800 or higher), and will increase as the ISO increases.

The mottled colored specks are even more obvious in images that are underexposed and lightened afterward in image processing software. You can buy aftermarket software for noise reduction, but it's best to use ISO 400 or lower whenever practical for the absolutely "cleanest" images.

Sensor noise may also be increased with long exposures under low-light conditions, as in night photography. However, when you activate the camera's noise reduction feature, exposures of one second or longer will receive extra processing to minimize the digital noise pattern. In most situations, the α100 produces images with very little digital noise at ISO settings up to 800 and acceptable digital noise at ISO 1600.

File Formats
A digital camera converts analog image information to digital data and records to a digital file. The α100 offers two distinct file formats: JPEG and RAW. It also offers another option: RAW & JPEG, which records each photo in both the RAW and the JPEG (Fine quality) formats simultaneously.

JPEG: Joint Photographic Experts Group, the most common format in digital photography, is actually a standard for compression of images rather than a true file format. Digital cameras use JPEG because its compression reduces file size, allowing more pictures to fit on a memory card.

RAW: A generic term for a format that has little or no internal processing applied by the camera. Most camera manufacturers have developed proprietary versions of RAW, and the α100's RAW files are noted by the suffix "ARW" (but I will often refer to ARW files with the generic term RAW).

Resolution
Resolution refers to the quantity of pixels being utilized. Virtually all of today's digital cameras give you choices about how many of the sensor's pixels to use when shooting pictures. You do not always need to employ the camera's maximum resolution. Your memory card will hold

Called "white balance," the ability to adjust digital cameras for the color temperature of the light falling on a subject offers a significant advantage over film cameras. Photographers no longer need to use filters, which block light, to correct color.

more images when the camera is set to record at lower resolutions, but it will not capture as much data; and the more digital information (higher resolution), the bigger print it is possible to make.

White Balance

Most pros who have shot film over the years can tell you about the challenges of balancing their light source with the film's response to the color of light. For example, daylight-balanced (outdoor) film used indoors under tungsten household lamps will produce pictures with an orange cast. Accurate color reproduction in this instance would require the use of a blue color-correction filter.

The color of light also varies in other circumstances, though our eyes and brain make natural adjustments so we do not notice this variation. Light is quite blue on an overcast day, even bluer in a shady area, green under fluorescent lighting, orange under tungsten lamps, and so on. In film photography, filters attached to the front of a lens can correct for the color cast by altering the color of the light so our subjects are rendered as we normally see them.

This has changed with digital cameras. Color correction is managed by the built-in white balance functions. The camera can automatically check the light, calculate the proper setting for its color temperature, and make the necessary modification. This automated system is programmed to produce pictures without color casts or inaccurate tones. However, this system is not foolproof, so user-selectable white balance overrides are also usually provided.

Cost of Shooting
While film cameras generally cost less than digital cameras, the cost of shooting digital is lower. A couple of reusable memory cards are much less expensive than a large supply of film, and there's no need to pay for processing or for printing every image on a roll of film. The more pictures you take, the sooner you will recoup the difference in the cost of an α100 versus the cost of a comparable 35mm film camera.

More importantly perhaps, you may become a better photographer when using a digital camera. Since you won't need to worry about the cost of film and processing, you'll be more likely to really "work" a subject, exploring it from various angles and trying a variety of creative photographic approaches. This can be liberating because it encourages greater creativity. Any shots that don't work out can simply be deleted.

Features and Functions

Although priced to compete with some of the entry-level D-SLRs, the α100 is a remarkably versatile model and possesses some technology not available in other cameras in the same class. While it's easy to use for those new to digital SLRs, the α100 will also satisfy experienced photographers thanks to its many advanced capabilities.

The α100 is a compact D-SLR that features a large rubberized handgrip as well as sizeable, easy-to-manipulate external controls. It's finished with a scratch-resistant matte black exterior over a strong magnesium alloy chassis. Its high-resolution, 2.5-inch (6.2 cm) color LCD monitor is comparably large for its class. This screen displays the necessary options during menu navigation as well as data about current settings while shooting. It also displays recorded images after they are taken. In after-shot viewing or in Playback mode, full shooting data—plus a histogram display—is available for each image.

The α100 is designed with fewer control buttons than some entry-level cameras, so it's less likely to intimidate a first time digital SLR user. However, it allows for many features to be selected with one of the two large dials (Mode dial and Function dial) on the camera's "shoulders." A range of additional functions is accessed electronically using the various menus.

⟡ *The Sony D-SLR α100 offers a number of advantages over less sophisticated point-and-shoot digital cameras, including a larger image-sensor, faster response time, and the ability to shoot with wide-angle or telephoto lenses.*

This is an autofocus camera, but it allows for manual focus fine-tuning in AF mode using the focus ring if Direct Manual Focus (DMF) is selected. Naturally, the α100 can be set for manual focus mode as well.

The camera features the Alpha lens mount, identical to the Konica Minolta Maxxum/Dynax A mount. Although it is not compatible with Minolta manual focus lenses (MD and MC), the camera accepts Maxxum/Dynax AF lenses made since 1985. While Sony does not guarantee that all such lenses are completely compatible, we doubt there will be many, if any, compatibility problems. (That includes the SSM series Maxxum/Dynax lenses with built-in Super Sonic Wave, or ultrasonic focus motors.) Naturally, all Sony brand G-series AF lenses—and the Carl Zeiss Alpha series made specifically for the Sony a system— are fully compatible.

The α100 also features Sony's latest processor, the BIONZ Image Processing Engine, to provide images with maximum detail, accurate colors, and minimal digital noise. It's very fast and allows you to fill your memory card shooting JPEGs at 3 frames per second. Even after taking a long burst of photos, the camera is usually ready for more shots. To derive maximum speed performance, use a high-speed memory card such as the Kingston 100x, Lexar 133x Pro, or the San-Disk Ultra or Extreme series.

A unique D-Range Optimizer (DRO) feature is made possible by the BIONZ engine. Three options are available: Off, Standard, and Advanced. The Optimizer makes gamma and tone adjustments. According to Sony, "DRO assures perfectly exposed pictures, especially when shooting high-contrast or strongly backlit scenes that can lead to loss of highlight and shadow detail."

Eye-start is a system that features two sensors located just below the viewfinder eyepiece (with its rubber cup). These detect the presence of the user as he or she places their face to the viewfinder, automatically starting the light metering and autofocus systems so the camera will be ready to shoot

An entirely new processor, BIONZ, offers several benefits, including improved processing speed, superb image quality, and a Dynamic Range Optimizer. Photo courtesy of Sony Corporation.

immediately. When that detection occurs, the LCD monitor is dimmed to conserve battery power.

Spend time with your α100, getting to know it well. Become familiar with each of the controls. Many of the abbreviations and icons used to denote the various features are common to other digital cameras, so they may already be familiar. Some are intuitive; for example, WB stands for white balance, AF/MF denotes autofocus/manual focus, AEL stands for auto exposure lock, and so on.

Sony α100 – Front View

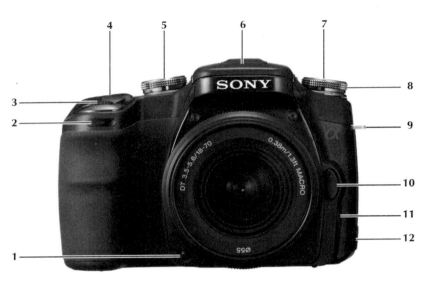

1. Depth-of-field preview button
2. Self-timer lamp
3. Control dial
4. Shutter button
5. Mode dial
6. Built-in flash
7. Function (Fn) button
8. Function (Fn) dial
9. Strap hook
10. Lens release button
11. Focus mode switch
12. DC-In terminal

Sony α100 – Rear View

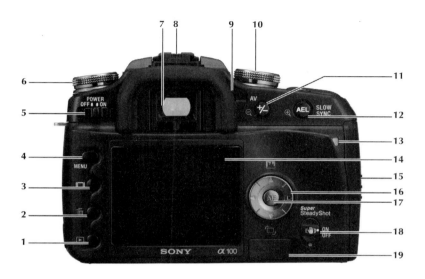

1. ▶ Playback button
2. 🗑 Delete button
3. |□| Display button
4. MENU button
5. Power switch
6. Function dial
7. Viewfinder
8. Accessory hot shoe
9. Diopter adjustment dial
10. Mode dial
11. +/− Exposure/
 ⊖ reduce button

12. AEL/ ⊕ enlarge button
13. Access lamp
14. LCD monitor
15. CF Card & Video/USB jack
 cover
16. Controller
17. Center button (Spot-AF)
18. (⟨🖐⟩) Super
 SteadyShot switch
19. Remote jack

Sony α100 – Top View

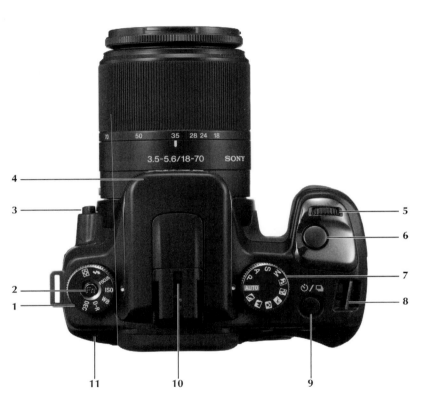

1. Function dial
2. Function button
3. Lens release button
4. Built-in flash
5. Control dial
6. Shutter button

7. Mode dial
8. Strap hook
9. ⟲/⧠ Drive button
10. Accessory shoe
11. Power switch

Overview of Features

Though compact, the α100 is a full-featured camera that competes with some of the more advanced and expensive models of other brands. It is easy to use in point-and-shoot modes, but is highly suitable for serious photography due to its versatility.

- A 10.2MP (effective) sensor with 3,872 x 2,592 pixel resolution, developed by Sony specifically for the α100.
- A 2.5″ LCD monitor provides higher resolution (230,000 pixels) than most cameras. It also possesses a wide viewing angle and new anti-reflection coating that makes the display more visible than others in bright light.
- The Eye-Start system quickly activates autofocus before depressing the shutter button.
- A sophisticated BIONZ Image Processing Engine maximizes detail and color integrity and minimizes digital noise.
- The Super SteadyShot (SSS) system compensates for camera shake. This in-camera CCD-Shift system stabilizes most Maxxum/Dynax and Alpha mount lenses, providing an advantage of 2–3.5 increments of shutter speed over non-stabilized cameras/lenses.
- The unique D-Range Optimizer makes brightness and tone adjustments in high-contrast lighting conditions— especially back lighting. In practical terms, the system provides increased shadow detail and better highlight detail under high-contrast lighting.
- An Anti-Dust system to shake loose dust particles from the sensor whenever the camera is turned off. The α100 is also equipped with special anti-static coating on the low-pass filter to minimize static electricity and dust attraction.
- A new battery that is rated to provide 750 shots on a single charge, assuming 50% flash usage (CIPA standard). Do note that the α100 is not compatible with the battery used by the Maxxum/Dynax cameras.

Specifications

Image Sensor: 23.6 x 15.8 mm CCD with RGB filter array and low-pass filter; 10.2 million recording pixels; 1.5x field of view crop.

Image Size: L:10MP; M:5.6MP; S:2.5MP.

Quality: JPEG Fine, JPEG Standard; RAW (ARW format); and RAW & JPEG (RAW+) formats.

Sensitivity: ISO 100 to 1600; also, *ISO 80 Low Key* and *ISO 200 High Key* selectable.

Viewfinder: Penta-mirror finder, 95% field of view; 0.83x magnification; Spherical Acute Matte focusing screen; diopter correction, -2.5 to +1; removable eyepiece cup; 20mm eye relief.

Shutter Speeds: 30 to 1/4000 sec. plus Bulb; top flash sync speed 1/160 or 1/125 when Super SteadyShot is active.

Exposure Modes: AUTO, Program (shiftable), Aperture and Shutter Priority AE, Manual, plus six scene modes.

Drive: Single frame and Continuous at up to 3 fps advance for an "unlimited" number of JPEGs; Self-timer.

Autofocus System: Nine point sensor with cross hatched central point; any sensor selectable; Single shot AF, Continuous predictive tracking AF and auto switching between AF modes; focus override in AF mode available; focus-assist beam with pre-flash; Eye-Start AF system.

Exposure Metering: Center weighted; Spot; 40-segment honeycomb pattern (evaluative); exposure and flash exposure compensation; AE Lock and AE bracketing for ambient light and/or flash.

White Balance: Automatic, Daylight, Shade, Cloudy, Tungsten, Fluorescent, Flash, and Custom WB; White Balance Fine Tuning and Bracketing; Color Temperature (2500-9900K) also selectable.

Image Adjustments: Standard, Vivid, Portrait, Landscape, Sunset, and Night View color modes in sRGB color space; B&W mode; also, Adobe RGB selectable without color mode options; contrast, color saturation, and sharpness adjustments; noise reduction selectable for exposures over one second.

Flash: Built-in, with manual control and pre-flash TTL; ADI metering with Maxxum D-series and Sony or Carl Zeiss Alpha lenses; Fill-flash, Flash cancel, Red-eye reduction, and Rear curtain sync modes; wireless off-camera TTL flash and high-speed sync available with certain flash units.

Power: One NP-FM55H Lithium-Ion rechargeable battery (1600 mAh); optional AC adapter.

Connectivity: USB 2.0 Hi-speed; Video out (NTSC or PAL); socket for remote control accessory.

Dimensions/Weight: 5.2 x 3.7 x 2.8 inches; 1.2 lb. (133 x 95 x 71mm; 545 g).

Software Supplied: Image Data Converter SR Ver.1.1 (for RAW enhancement and conversion) and Picture Motion Browser.

Other Features: Orientation sensor for LCD data and images; USB 2.0 High Speed output; accepts CompactFlash and, with adapter, Memory Stick Duo or PRO Duo cards.

Optional Accessories: Compatible with Maxxum/Dynax D-series flash units and Sony HVL flash units; also with other Konica Minolta flash units with optional adapter; accepts new Sony Alpha series accessories plus a wide range of Maxxum/Dynax accessories (but not batteries or battery grips).

The power switch is conveniently located under the Function dial, where it can be easily pushed on or off with your left thumb as you hold the camera in the shooting position.

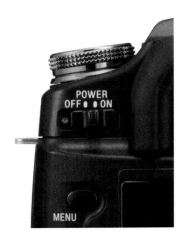

Camera Activation

Power Switch
The main power switch is located on back of the camera in the upper right corner. This switch slides right to turn ON and left to turn OFF.

Power Save
The α100 will basically shut down if it is on but has not been operated for a given length of time (the default is three minutes). This is known as Power save and is meant to save battery power. Simply press the shutter button to reactivate the camera so it is ready to shoot.

You can use Setup menu 3 🔧3 to vary the length of inoperative time before the camera will automatically begin Power save mode. See page 98 for details.

External Ports
The camera features several covered terminals for attaching accessories. On the back, you will find a port for the optional AC Adapter AC-VQ900AM and the remote control terminal. The optional remote cords RM-S1AM and the longer RM-L1AM can be used to remotely trigger the shutter, which helps to eliminate camera vibration during long exposures.

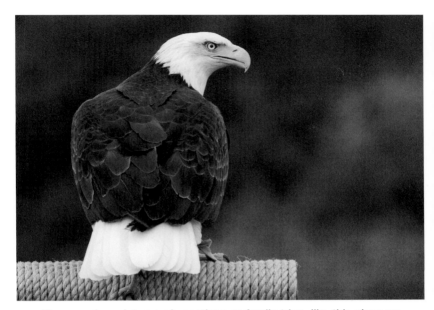

You can view pictures of vacations or family trips, like this close-up of a bald eagle at the zoo, on your television by connecting the included video cable from the α100's video jack to your TV's video input jack.

On the right side of the camera body you will find the card-slot door covering the memory card slot and the USB port/Video Out terminal. The USB cable included in the α100 camera kit connects the camera to a computer's USB port for downloading image files, or to some recent Pict-Bridge compatible printers for printing directly from the camera (see pages 203-204 for more information). The camera also accepts the second cable included in the kit. This is used for connecting the camera to a television monitor's video-in port for showing images on a large screen.

Resetting Controls
Once you become familiar with your α100 you are likely to change settings often. Sometimes you may want to quickly return to the original default settings. To do so, use the Reset option in Recording menu 2 (see page 85 for details).

Camera Controls

There are several important dials on the α100 that are used
to navigate and manage camera functions.

*The Mode dial selects options
for exposure. The AUTO and the
picture icons indicate camera-
controlled preset modes, while
P, A, S, and M give the user par-
tial or full control over exposure
settings.*

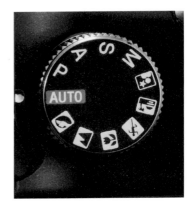

The Mode Dial
Located on the camera's top right shoulder, this dial is used
for selecting the exposure mode. The abbreviations P, A, S,
and M denote Program mode (shiftable, so you can change
the aperture/shutter speed combination), Aperture Priority,
Shutter Priority (both semi-automatic), and Manual (for man-
ual selection of both aperture and shutter speed using guid-
ance from the camera's light meter, but without automation.)
AUTO denotes fully automatic (no aperture/shutter speed
shift available), while the picture icons denote Portrait,
Landscape, Macro (close-up), Sports Action, Sunset, and
Night View/Portrait, each designed to produce good photos
with the specific type of scene or subject.

Controller
This pad on the back of the camera has arrow keys that
allow you to scroll up, down, right, and left. Additionally,
use the up arrow in instant review or in Playback mode to
show shooting data, histogram, and the Luminance Limit
Warning. The Center button (also known as the Spot-AF but-
ton) in the middle of the pad is often used as an "Enter" but-

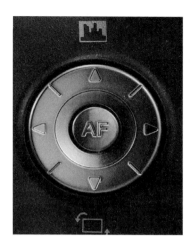

The Controller on back of the camera is used in conjunction with menu displays to scroll (arrows) and confirm (Center button) desired settings.

ton to confirm a selection in the electronic menu or a Function screen. It's marked AF because it has another function: When Wide Area autofocus is being used, pressing the AF button switches all sensitivity to the single (cross-hatched) central spot focus detection point.

Function Dial and Function (Fn) Button

On the camera's top left shoulder, this dial surrounds a button marked Fn for function and allows you to quickly and

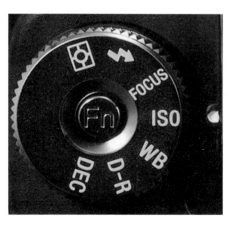

The Function dial is not found on many other D-SLRs. It gives quick access to key settings without going through the menu system.

conveniently set the light metering pattern (multisegment, center weighted, or spot). It also controls selection of flash mode, flash exposure compensation, focus mode, ISO, White Balance, D-Range Optimizer, and Digital Effects and Color modes. Rotate the dial to the desired feature and press the Fn button. A screen then appears on the LCD monitor with pertinent options for the selected feature. You can use the keys on the Controller to scroll through options, and press the Center button to enter and confirm any selection.

Power Sources

The single proprietary rechargeable Sony Stamina Lithium-Ion (Li-ion) battery (NP-FM55h, included with the camera) will power about 750 frames per charge, though you'll get fewer shots if you frequently use the built-in flash or the image playback feature. The number of shots per charge is also dependent on the external temperature; if bitter cold outside, the battery will drain more quickly. Maximum recharging time for a dead battery is about 175 minutes for a Normal Charge or 235 minutes for a Full Charge.

Note: The α100 is programmed to turn off the LCD monitor and most other functions when the camera is not in use in order to conserve battery power. To turn them back on, just press any camera button. You can set the period of time that the LCD will be on (*LCD Backlight*) to 5, 10, 30, or 60 seconds (see page 98).

The camera does not accept universally available batteries, such as AAs, so it is wise to carry a spare NP-FM55H, especially on long outings. The camera can also be plugged into household power using the optional AC adapter (be sure to use the correct power cord for your geographic region). This option is useful for preventing battery drain if you download images directly from the camera to a computer, or plan to print directly from the camera while it's connected to a printer with a USB cable.

The Viewfinder

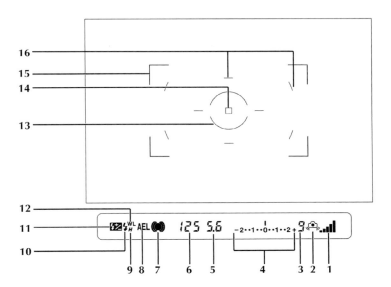

1. Super SteadyShot scale
2. Camera shake warning
3. Remaining number of recordable images
4. EV scale
5. Aperture
6. Shutter speed
7. Focus indicator
8. AE Lock

9. High-speed sync
10. Flash charge indicator
11. Flash compensation
12. Wireless flash
13. Spot-metering area
14. Spot AF frame
15. Wide focus area
16. Local focus frames (8 total)

The Viewfinder

The α100 uses an eye-level viewfinder with a Spherical Acute Matte focusing screen and a large, bright, lightweight, and specially coated penta mirror (instead of the heavier, all-glass pentaprism that is used in some cameras). The finder shows 95% of the image area at 0.83x magnification when using a 50mm lens focused at infinity. That level of magnification is about average in the affordable D-SLR category. The eyepoint is 20mm, indicating that you can see the entire image area when holding the camera as far as 20mm from your eye. This is beneficial for those who wear eyeglasses when shooting, and are unable to hold the eyepiece closer to their eyes.

The viewfinder eyepiece allows for a -2.5 to +1 diopter adjustment. Adjustments are made using the small diopter adjustment dial on the right side of the rubber eyepiece cup on the back of the camera. If you normally wear eyeglasses, try this feature to determine whether it's adequate to allow you to shoot effectively without your corrective lenses. If not, then make the adjustment while wearing your eyeglasses or ask your retailer about the optional Sony Eyepiece Correctors, which offer higher strengths than those built into the camera.

The viewfinder includes a data display panel with information about camera settings in use. Nine AF area points and the spot metering circle are etched on the viewfinder's ground glass screen. When using the camera in autofocus, one or more of the AF area points light up briefly to indicate the point of focus.

There's also an anti-shake scale in the display panel showing the extent of camera shake compensation that the Super SteadyShot system is providing at any time. The more bars that appear, the more aggressively the system is working. When five bars appear, the system may not be fully successful in correcting camera shake; select a higher ISO for a faster shutter speed or brace the camera (or your elbows) on a firm support.

The LCD Monitor

The α100 employs a single, full color LCD screen (2.5 inches; 6.2 cm) on the back of the camera that displays shooting data as well as images (after they are taken). This large LCD is a high resolution screen (230,000 dots) with an antireflective coating that helps you view the monitor even in bright conditions when glare would otherwise be a problem. The LCD not only displays important recording data and camera settings, it lets you review pictures stored on your memory card as well as navigate within the vital menu system to control many of the camera's operations.

In order to save battery power, the LCD automatically darkens after a period of non-use. (The default is five seconds, but the time period can be adjusted in Setup Menu 3, see page 98.) Touching any button or turning any dial or knob quickly reactivates the monitor because the information is always live on the screen whenever the camera's systems are active. Only its backlight automatically switches off to save power.

You cannot use the LCD monitor for composing or viewing your picture before shooting, as you can with point-and-shoot digital cameras. However the monitor does display an image for quick review immediately after shooting via instant playback. You can set the length of time you want the instant-playback image to show before the screen returns to data display. Or you can examine recorded images from your memory card at any time for as long as you want by pressing the playback button ▶ (back of camera in lower left corner).

Data Display
Data is displayed on the LCD monitor when images or menus are not being viewed. You can even make the letters and numbers larger than default—simply press the display button |O| on the back of the camera two times, though less data will then be displayed. When the α100 is placed in the vertical shooting position, the display automatically rotates for ease of viewing (see page 94).

41

LCD Monitor Display (Recording Information)

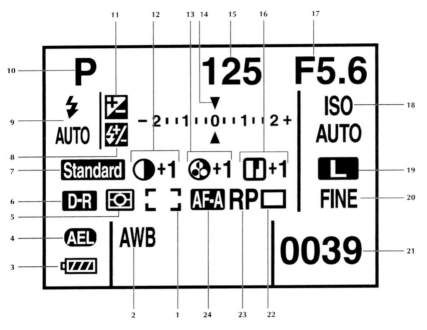

1. AF area
2. White balance
3. Battery status
4. AE Lock
5. Metering mode
6. D-Range Optimizer
7. Color mode
8. Flash compensation
9. Flash mode
10. Exposure mode setting
11. Exposure compensation
12. Contrast setting
13. Saturation setting
14. EV scale
15. Shutter speed
16. Sharpness setting
17. Aperture (f/stop)
18. ISO sensitivity
19. Image size
20. Image quality
21. Remaining number of recordable images
22. Drive mode
23. Release priority
24. Autofocus (AF) mode

The display for Recording mode presents a wide scope of useful information on settings and camera operations, ranging from readouts telling which exposure mode and f/stop are in use to battery status and the number of frames left on

The camera can be programmed to automatically turn off the LCD monitor when you look through the viewfinder. This is a handy feature that conserves battery power.

your memory card. You can scroll between the full and partial display of recording information (or turn the monitor off) by repeatedly pressing the display button. You can also turn the LCD monitor off by programming it in Custom Menu 2 (see page 94) so it switches off automatically when you look through the viewfinder. This conserves power and eliminates the distraction of seeing the display while shooting. When you move the camera away from the shooting position, the data display switches back on automatically.

Note: When the LCD monitor is turned off, images are not displayed after they are taken.

Playback Options
Instant playback (image review) occurs automatically after each scene is shot. The default viewing period is two seconds, which can be changed in Recording menu 1 (see page 82).

Although the feature for instant playback is useful for a quick look, the full Playback mode offers you the ability to take your time and review all of the images stored on your memory card. Access this mode by pressing the playback button ▶ . Use either the Control dial or the left/right Controller keys to scroll through the images. Use the down key to rotate images.

To view a photo's histogram and Luminance Limit Warning, which appear on a screen that also includes certain file and shooting information, press the up key on the Controller while in instant playback or in the full Playback mode. These features will allow you to evaluate the exposure as discussed in detail on pages 142-147.

There are two additional options in Playback mode that are quite useful. The first is a magnification feature. Use it to check sharpness in specific areas of an image, look for red-eye, gauge facial expressions in people pictures, and so on. In order to magnify an image in Playback mode, press the AEL button located on back of the camera in the top right corner; it's also marked with a magnifying glass and a plus symbol ⊕ . You can now scroll around the image using any of the four keys on the controller to see different portions of the enlarged picture.

To decrease magnification, press the exposure button (+/- on back of camera to right of viewfinder). It's also marked with a magnifying glass and a minus symbol ⊖ . To return to full image viewing, press the Center (AF) button in the middle of the Controller on back of the camera.

The second handy feature is the ability to create an index display for reviewing thumbnails of multiple images. Simply press the ▢ button twice while in Playback mode. This feature is useful to search for a shot stored on your memory card because you can look at more than one picture at a time (but the images are small). The number of thumbnails displayed can be changed from 9 (default) to 4 or 16 using the Playback Menu 1, as discussed on page 88.

You can also use Playback mode to review images as a slide show on the LCD monitor (see Playback Menu 2 , page 88 for setup information). Each picture stored on your memory card will display for five seconds before the next image automatically appears.

Deleting Images

You can delete pictures one at a time in either instant review or in Playback mode. Simply press the delete button 🗑 (located on back of camera in lower left) while an image is displayed. Scroll using the Controller keys to highlight YES on the confirmation screen, then press the Center button to complete the single image deletion.

In addition to this feature, the α100 provides the ability to delete as many images as you specify, including the option to erase all images in a folder. Use the delete feature accessible through Playback Menu 1 (see page 86).

Note: Although there is no in-camera method for recovering deleted images, several companies market software that's designed for this purpose. These programs do not provide a 100% success rate, but some are quite good at recovering deleted JPEGs and, sometimes, RAW files. Some memory cards even come with such software. Look for reviews on the Internet through a web search using keywords such as, "image recovery software programs."

Protect Images from Deletion

Before deleting any images, you may want to protect important ones from unintentional erasure using the lock feature. You can use Playback Menu 1 to lock any number of images you choose, protecting them from deletion. You can always remove the lock from any image at a later time. See page 87 for details.

Caution: All images, including those protected using the lock feature, will be erased when formatting the memory card.

Because the camera's CCD sensor is smaller than a 35mm film frame, the view through a lens is different. A 1.5 magnification factor is used to compute the focal length that would be the equivalent on a 35mm camera. Photo courtesy of Sony Corporation.

The CCD Imaging Sensor

While the Sony 10 MP sensor records images in full color, its individual pixels are actually not able to record color values at all. Each pixel captures a portion of the total light falling on the sensor, and they are only able to record the intensity of the light. Therefore, filters are placed in front of the pixels so each can only record one of the three primary colors (red, green, and blue) of light. These filters are arranged in a specific order, most commonly using the Bayer pattern where there are twice as many green pixels as there are red and blue.

When the light projected by the lens comes into contact with the imaging sensor during exposure, the light-sensitive pixels accumulate an electrical charge. More light striking a particular pixel translates into a stronger electrical charge. The electrical charge for each pixel is converted into a specific value based on the strength of the charge so that the camera can actually process the data.

Because each pixel on the sensor only records the value of one of the primary colors, full color must be interpolated based on information from adjacent pixels. The final image

Due to the 1.5 magnification factor, a 300mm lens on the α100 has a view equivalent to a 450mm lens on a 35mm SLR. This is a real benefit in telephoto photography such as this shot of a radio-controlled airplane.

data is then written to the camera's memory card as an image file. An exception to this would be the RAW capture format, which records raw data (actual pixel values) from the sensor and stores it in a special file format (ARW) that needs to be processed using special software.

In addition to the Bayer pattern filter, a low pass anti-aliasing filter is located in front of the sensor. This reduces the wavy colors and rippled surface patterns (moiré) that can occur when we photograph small, patterned areas with a camera that uses a high-resolution sensor.

The Sensor and Effective Focal Lengths
As with the vast majority of digital cameras, the α100's sensor is smaller than a 35mm film frame, which measures 24 x 36 mm. Because of the smaller 23.6 x 15.8 mm size, the view through a lens is different than it would be if mounted

on a 35mm camera. Many seasoned photographers like to think in 35mm SLR terms, so they often describe lenses on digital SLRs by their "effective focal lengths." To calculate this effective focal length, multiply by 1.5. For example, a 28–75mm zoom becomes equivalent to a 42–112.5mm zoom in the 35mm format. The smaller sensor reduces the wide-angle capability of the lens, but increases its capacity for telephoto zoom.

This 1.5x factor for effective focal length, or "focal length magnification," is actually a field-of-view crop. In other words, the focal length is not actually increased. The apparent magnification occurs because the small sensor records a smaller portion of the scene than a larger 35mm film frame would. Consequently, the image appears as if it had been taken with a longer lens, one with a narrower field of view that encompasses less of any scene.

This factor is certainly useful in wildlife and sports photography as it reduces the need to use super telephoto lenses (i.e., 500mm or greater) for tight shots of a distant subject—a moderate telephoto lens (such as the long end of a 75-300mm zoom) will often do the job. But in wide-angle photography, the effective focal length magnification is a drawback because we need extremely short focal lengths to create images with a true ultra-wide effect. That's why Sony is offering shorter, or wider, lenses, such as the 11–18mm zoom; at its short end, this lens provides the ultra wide field of view that we would expect from a 16.5mm lens on a 35mm camera.

Cleaning the CCD Sensor
Whenever you shut the camera off, the Anti-Dust system will shake loose particles off the CCD sensor. However, sticky particles or dust in dry climates may remain on the sensor. Prevention of dust accumulation is definitely preferable to cleaning. You'll know if the sensor becomes dusty because spots will appear in your images. In that case, you may decide to clean the sensor. The exact method for doing so requires the use of the camera's electronic menu (see page 100).

How to Remove the Memory Card

To remove the memory card, first turn the camera off. Open the card-slot door and find the small card-eject lever; press it once to eject the card; you can then pull it out easily. The lever will stay in the down position so you can close the card-slot door.

Caution: Be certain the red access lamp on back of the camera in the upper right corner is not illuminated. When it is lit, the camera is writing data to the card. Removing a card while data is being recorded can damage the card and cause a permanent loss of image data. To avoid such damage, always turn the camera off before inserting or removing the memory card.

Camera Care and Cleaning

Keep your α100 and all lenses clean and well protected when not shooting. Do not expose the camera or lens to water, dust, sand, or salt. A camera bag and a clean, dry storage environment should prevent dust and dirt buildup. Always keep the body cap on the α100 when a lens is not mounted; this will prevent dust and contaminants from getting inside the body and settling on the sensor. Keep the front and rear caps on your lenses as well. When you set the camera down, be sure that the lens is not pointing toward the sun, to prevent damage to the CCD sensor.

Always switch the camera off before mounting or removing a lens. This will minimize static electricity, reducing the amount of dust that will be attracted to the CCD sensor. When shooting in a location with a great deal of sand or dust, do your best to change lenses quickly in a protected spot. Hold the camera pointing downward when changing lenses.

In addition, do not leave the camera in hot locations, such as the interior of an automobile parked in the sun. Try to minimize exposure to extreme humidity. In such conditions, keep the camera/lens in a camera bag when not in use.

When storing the camera for more than a week, remove the battery and the memory card. In order to minimize the risk of lost data, do not place the card near a magnet (as in audio speakers) or near any appliance that produces high static electricity discharge. And keep your camera bag immaculately clean; use a vacuum cleaner to remove dust and other contaminants from the bag, on a regular basis.

Put together a basic camera care kit, including two microfiber cloths and photographic lens cleaning solution, plus a large blower bulb for blowing dust out of the camera interior. All such accessories are available from photo retail stores. Also carry a soft, absorbent cotton cloth (an old T-shirt perhaps) to dry of the exterior or the camera and lens when working in damp conditions. (Do not shoot in rain or snow unless the camera and lens are well protected.)

Dedicate a microfiber cloth for the purpose of cleaning your lenses; do not use it for other purposes, such as cleaning a smudged LCD monitor; use a cloth of a different color for that. In most cases, a gentle breath of warm air on the front element plus a quick wipe with the microfiber cloth is all you do to clean your lens. To remove stubborn smears or fingerprints, use a photographic lens cleaner solution. Do not use solutions designed for other purposes such as cleaning eyeglass lenses. Apply a drop of solution to a small part of the microfiber cloth; do not pour it onto the front or rear element of the lens because liquid may seep into the optics. Wipe away any of the solution using a dry part of the microfiber cloth.

Take care to keep your camera as clean as possible to eliminate the *possibility of dust getting on the camera's imaging sensor. Change lenses quickly, with the camera's mirror box pointed downward during the process. Always use lens and body caps, and store your gear in a clean camera bag. © Kevin Kopp*

Digital Recording and In-Camera Processing

File Formats

A digital camera processes analog image information from its sensor and converts it to digital data. Typically, the conversion results in 8- or 12-bit color data for each of three different color channels: red, green, and blue. A bit is the smallest piece of information that a computer uses—an acronym for binary digit (0 or 1, off or on).

One great feature of the α100 is its ability to record a RAW file in Sony's proprietary ARW format. What sets RAW files apart is that they have undergone little or no internal processing by the camera. These files also contain 12-bit color information, which is considerably more data than an 8-bit JPEG. Also, RAW files offer greater latitude for making corrections during image processing. However, you must use editing software that is compatible with this particular RAW format. Sony bundles just such a program with the camera: Image Data Converter SR. You can also use Adobe Photoshop CS2, Elements version 3.0 or later, or another brand of software that is compatible with Sony's ARW format.

The other recording option with the α100 is JPEG. this is an international standard for the compression of images, is the most common file type created by digital cameras. It reduces the size of the file, allowing more pictures to fit on a memory card. When a photo is recorded in JPEG form, proprietary processing takes effect. The camera's processor evaluates the 12-bit image, makes adjustments to it, and compresses the image

Sony offers different file choices with the α100. JPEG files require less processing and take up less room on the memory card. However, for professional-quality photos, such as this, you may want to use the RAW format. It provides greater control over color and the ability to fine-tune exposure using RAW conversion software.

with a reduced color depth of 8-bit. Because this process dis-
cards what it deems "redundant" data, JPEG compression is
referred to as "lossy." When the file is opened in image pro-
cessing software, the program will rebuild the JPEG file based
on existing data. However, the finer the JPEG quality option
that you select, the less original data is discarded.

After the JPEG file is downloaded and enhanced in
image-processing software, it should be saved as a TIFF or
in the image-processing software's native format (such as
PhotoShop's psd). That will prevent further loss of quality
that can occur when re-saving a file as JPEG, with addi-
tional compression.

Both RAW and JPEG files can give excellent results. The
unprocessed data of a RAW file (which can be converted to
16-bit color depth using a RAW converter software program)
can be helpful when faced with tough exposure situations, but
the small size of the JPEG file is faster and easier to deal with.

Both formats work extremely well. The most important factor
in deciding which will work best for you is your own personal
shooting and working style. If you want to shoot quickly and
spend less time in front of the computer, JPEG might be the best
choice. If you loved working in the darkroom and processing
film, then RAW is a great continuation of that process. If you
are dealing with problematic lighting, shoot in RAW for the
superior correction possibilities available with the ARW format
files. If you have tons of images to deal with, JPEG may be the
most efficient because you will not need to first convert every
photo using the special software.

Image Size (Resolution)

For digital cameras, resolution indicates the number of indi-
vidual pixels contained on the imaging sensor. This is usu-
ally expressed in "megapixels" (MP), an abbreviation for
millions of pixels. Thus, a 10-megapixel camera has 10 mil-
lion pixels covering the sensor.

Make sure you take extra memory cards on vacation, so you will always be able to shoot JPEG files at the highest resolution/lowest compression settings. This will give you more options than smaller files for cropping and enlarging photos after the trip.

You don't always have to utilize the camera's maximum resolution. The α100 offers the choice of three different JPEG resolution settings, or image sizes, in which to record. Generally it is best to use the highest setting available to take the most finely detailed pictures. This also gives you more flexibility to crop or to make large prints. You can always reduce resolution with image-processing software in the computer.

Below are the three options available when selecting JPEG image size. Use 📷1 to select *Image size* (see page 80).

- **Large** (L:10M): 3872 pixels x 2592 pixels (10 megapixels)
- **Medium** (M:5.6M): 2896x1936 pixels (5.6 megapixels).
- **Small** (S:2.5M): 1920x1280 pixels (2.5 megapixels).

In a high-contrast scene, it's worth shooting in RAW for the added benefit of using the exposure, contrast, and brightness adjustments in the converter software. If you want to do additional work on the images in Photoshop, convert the RAW images to 16-bit TIFFs.

There may be situations where it is preferable to shoot at less than maximum resolution. Lower resolution (smaller) image files save storage space and processing time. You can fit more of them on your memory card than those captured using higher resolution settings. Smaller files used in emails or on web pages can be handled by servers and browsers more easily and quickly than large files.

Quality (Compression)

Image quality refers to the amount of compression you want the in-camera processing engine to apply. No compression is applied to RAW files (see the next section). The *Fine* option produces less compression than the *Standard* option for JPEGs, so the file will be larger. Select *Standard (STD)*, for example, when you don't have much capacity left on your

memory card. However, be aware that increased compression creates an image that is less fine. When data is restored and highly compressed files are opened, some "artifacts," such as jagged subject edges, may appear.

To set the image quality, use Recording Menu 1 **◘1** and choose from the following options (see page 81 for details on how to set *Quality*):

- **RAW**: (ARW format) No compression.
- **RAW & JPEG**: No RAW compression, least amount of JPEG compression.
- **Fine**: Applies the least amount of compression to JPEG files in order to maintain high quality.
- **Standard**: Applies a higher amount of compression to JPEGs, and hence lower quality.

ARW Format RAW Files

When you record using the camera's RAW mode, the files are always created at the maximum resolution of 10.2 MP. They also receive little in-camera processing and contain more color and tone information than JPEGs. Consequently, they are significantly larger and use more memory in both your card and your computer. I recommend a high capacity memory card, at least 2 gigabytes (GB), if you plan to frequently shoot in RAW format.

Because the ARW format is not compatible with all image-processing programs, special software must be used to convert these files to a format (such as TIFF) that is recognized by standard image-processing programs. The Sony Image Data Converter SR software will work, but you can also use other image-processing programs, such as Adobe Photoshop CS2 or Elements version 3.0 or higher.

These ARW files offer greater dynamic range (latitude) than JPEGs, as well as more flexibility in computer processing to affect exposure, color temperature, white bal-

JPEGs are a good choice for photography of average outdoor scenes. This JPEG image was fine right out of the camera and required only slight tweaking with Levels and Unsharp Mask in Photoshop.

ance, color saturation and contrast. You have more options about how to process and use that information than you do with JPEGs.

RAW & JPEG Recording

The α100 gives you the option to shoot an ARW format file plus a JPEG image at the same time, which generates largest/finest JPEG along with the naturally large RAW file. The JPEG size and quality are "fixed" in the RAW & JPEG mode and cannot be changed (as is possible in some other brands of cameras).

To select this option, again use the *Quality* option in **�‌1** .

This recording mode can be useful if you want JPEGs for making prints quickly as well as RAW files for later processing in your RAW converter software. The combination of RAW and JPEG means a great deal of data that must be recorded to the memory card. Hence, this option will fill your card quickly and you will be able to shoot only three or four images in a sequence, depending on the speed of your card, since the camera is busy writing data to the memory card.

Both JPEG and RAW files include data about all camera settings in compliance with EXIF 2.2 (EXIF stands for Exchangeable Image File Format). This allows you to check shooting data when viewing an image in-camera and also in a computer. The EXIF data is also employed by some printers when printing directly from the camera via a USB cable.

Approximate File Sizes

The chart below shows the size of files in megabytes (MB) with the various format, quality, and resolution options offered by the α100. These are approximate since file size can vary depending on the amount of fine detail in an image.

Do note that these are the file sizes on the memory card. When you later open a JPEG in your computer, the JPEG compression will be reversed: Your imaging program will reconstitute the data (by adding pixels) that was discarded during in-camera processing. Hence, the in-computer JPEG file will be much larger. For example, a Large/Fine JPEG will be a full 28.7 MB in size. A RAW file will also be much larger after it is processed by the special software and converted to a format such as TIFF; the file will then be about 28.7 MB in size.

Quality	Large	Medium	Small
ARW (RAW)	9.58 MB	NA	NA
JPEG Fine	3.71 MB	2.97 MB	0.98 MB
JPEG Standard	2.4 MB	1.32 MB	0.67 MB
RAW & JPEG	13.29 MB (9.58 + 3.71)	NA	NA

Memory Card Capacity

The following estimates are approximate since actual file size can vary depending on the amount of fine detail in an image. These values apply to the use of a 1GB memory card.

Quality	Size	Approx photo files per card
ARW (RAW)	NA	65
JPEG Fine	Large	242
JPEG Standard	Large	377
JPEG Fine	Medium	419
JPEG Standard	Medium	640
JPEG Fine	Small	867
JPEG Standard	Small	1262
RAW & JPEG		51 RAW and 51 JPEG

RAW vs. JPEG

As noted, the amount of data in RAW files allows more adjustment latitude in image-processing software for color, white balance, contrast, and exposure without file degradation that can occur with JPEGs due to over processing in the computer. Generally you can also expect more pleasing prints at larger sizes (e.g. 13 x 19 inches—33 x 48 cm) from files originally shot in RAW.

Note: In RAW capture, the camera's processor records the in-camera settings used for such aspects as color saturation, color mode, contrast, white balance and sharpness. However, those aspects are not actually processed into the RAW file by the camera as they are with JPEGs. Hence, you can retain the in-camera settings or change them as desired with a RAW converter software program.

Let's say you are shooting inside a stadium under sodium-vapor lighting and you forget to change from Automatic White Balance. At the end of the day you notice all your images exhibit a strong color cast. Or, perhaps your exposure was a bit off for some of the shots at one end of the field. You'll usually have better results correcting these types of problems (using ARW format compatible software) if you were shooting in RAW capture mode.

While no software can work miracles with a grossly over or underexposed image, you should be able to correct moderate exposure errors (plus or minus one stop or EV) without giving the RAW image an artificial look. As well, major changes can be made to other aspects of an image, such as color, contrast, and white balance, without negative effects on the pixels.

Yet working with RAW does have certain drawbacks. The larger RAW files consume more space on a memory card than JPEGs. In addition, converting and adjusting ARW format files—before a final fine-tuning in your conventional imaging software—adds extra post-processing time. That can be a problem after you return from a long trip with hundreds of images.

The choice between RAW and JPEG is up to you. Determine the advantages and limitations of each and use what works best for your situation.

White Balance

Unlike the film used in conventional cameras, the sensors in digital cameras can be adjusted for different color temperatures of light. In other words, we can cause the camera to produce a natural-looking image, rendering whites as pure white in various types of lighting. When the whites are accurate, other tones are accurate as well, without a strong color cast. This is known as adjusting the white balance (WB).

White Balance—How It Works

Every light source emits a different range of wavelengths, varying from primarily short (appearing blue) to primarily long (appearing red.) Even the light from the sun can vary. It is cooler (bluer) on overcast days than during a sunrise or sunset (warmer, redder). While our brain perceptually adjusts for these differences, photographic film and digital sensors record them more objectively.

The color of light is defined numerically using the Kelvin color temperature scale. Lower Kelvin temperatures denote the warm, reddish light produced by a bonfire, an incandescent lamp, and the sun when it is low in the sky. Higher Kelvin temperatures denote the cool, bluish light at twilight, on heavily overcast days, or in a shady area.

On the Kelvin scale, full sunlight (mid day) is typically between 5100K and 5500K. The light on an overcast day is usually between 5500K and 6500K. In full shade, the light is even bluer: typically between 7000K and 8000K. The range provided for these different types of light is quite broad because it's affected by the exact time of day, the extent of the clouds that filter the light from the sun, the time of year, and atmospheric factors such as haze, smog, fog, or dust particles in the air.

Artificial light sources also produce light with certain color temperatures. Household tungsten lamps produce light with an orange cast (about 3200K). Most fluorescent tubes produce greenish light. Unusual lamps, such as sodium vapor and mercury vapor, produce light with a strange color that can be difficult to define.

In order to produce images with clean whites (and hence, accurate tones overall), digital cameras can be adjusted for the specific color temperature produced by these various light sources. This is referred to as white balance (WB). You can set WB with your α100, including an option called Auto White Balance (AWB) that attempts to automatically detect the type of existing light.

Auto White Balance (AWB) usually works well outdoors in average daylight. However, it is fun to experiment with white balance. For example, you might set the camera for Tungsten WB to add an exaggerated blue color cast to a peacock's feathers.

In addition, your α100 provides several other options for controlling white balance in a broad variety of lighting conditions. Some of the advanced features are straightforward and intuitive. Others are complex, of the type you would expect in a camera designed for professional photographers. While you may not plan to use all of the diverse options, it's worth understanding how they work and why they might be useful.

To select from the white balance options, use the Function dial. Rotate it to WB and confirm by pressing the Fn button. Then scroll to the desired white balance mode listed on the LCD monitor using the up/down keys on the Controller.

Auto White Balance AWB

This option is designed to analyze the color of light and set an appropriate color temperature to render whites as white. This system works quite well outdoors, especially on sunny or partly cloudy days, and indoors with flash. It's an especially useful choice when the light is changing rapidly (from sunny to cloudy to sunny again), or when shooting subjects that move from one type of lighting to another—sunlight to shadow, for example. But AWB does not always work so well under manufactured lighting such as tungsten or sodium vapor.

Preset White Balance Selections

You can usually get more accurate white balance rendition in mixed or artificial lighting than AWB by selecting a specific WB setting—called a preset—designed specifically for those conditions.

To select a preset WB, scroll down to the second option in the LCD monitor and then scroll right. Now, several white balance preset options will be visible, each with an icon and a description in words: Daylight ☀ , Shade 🝔 , Cloudy ☁ , Tungsten (household lamps) ✲ , Fluorescent ☲ , and Flash ⚡︎ᴡʙ . Scroll to the desired option with the Controller keys or the camera's Control dial. When you reach the one that is closest to the actual lighting conditions, press the Center button to confirm your selection.

Note: When using flash merely to lighten shadows in a scene where sunlight (or another light source) is the primary source of illumination, do not select the Flash white balance preset. Instead, use AWB or make your white balance selection based on the type of illumination that is the main light source for the shot. Reserve the Flash preset for low light photography when the subject will be primarily lit by the electronic flash.

Preset WB Levels Adjustment: You can fine-tune the white balance level of the particular setting (use the up/down keys once you have selected your WB preset). Select a plus (+) factor (up)

for a warmer (more red/yellow) effect. Or use the down key to set a minus (-) factor for a cooler (more bluish) effect. You can make adjustments within a range from +3 to -3.

You may find the WB levels adjustment option useful, however there is no way to determine the effect that any specific setting will produce before you take a photo. Hence, this feature calls for a lot of trial-and-error experimentation. You may decide to permanently leave the α100 set to a −1 factor for Cloudy WB if you find that the camera routinely makes images that are slightly too yellow on overcast days, for example. Or permanently set a +1 factor for Flash WB if you find the camera routinely produces images that are slightly too blue when using flash.

Once you have set a WB level adjustment, the camera will retain that setting until you readjust it, even after turning the camera off. It will be used whenever you select a specific white balance preset in the future.

Hint: WB levels adjustment is not very scientific because the exact color of light often varies within a broad range, as on a cloudy day, for example. When shooting in lighting conditions where the camera routinely makes images with inaccurate white balance, I strongly recommend using the Custom WB feature ☒ instead.

Creative Use of Preset White Balance: Using the "wrong" white balance setting can yield some interesting creative effects. For example, the ♣ setting can be used when the sun is shining brightly to create an effect resembling that produced by a warming filter. The ♨ setting produces a milder warming effect, while the ♠ setting produces a very obvious yellow/orange color cast.

The Tungsten setting produces the opposite—a strong blue cast, useful with some winter scenes for a much "cooler" effect. Experiment with using the various preset choices for creative purposes. You can always check the results in the camera's LCD monitor.

Custom White Balance 🌼

This feature allows you to set the white balance value for any type of lighting. Though a sophisticated function, it is not overly complicated to set. It is well worth the bit of extra effort to learn because this setting virtually guarantees good white balance under any unusual or tricky lighting condition.

Note: Custom WB applies only to photographs where flash is not the primary light source. If you routinely use flash, stick with the preset option, perhaps using the WB levels adjustment if you prefer a warmer or cooler result.

For Custom WB, a sheet of white paper or a gray card is needed as a target in order to calibrate the camera. In order to set Custom White Balance for a specific lighting condition, follow these steps exactly as specified. It is a good idea to photocopy them for handy reference while you're out shooting.

1. Set the Function dial to WB, press the Fn button and use the down key to scroll to the fourth item 🌼 from the screen that appears in the LCD monitor.

2. Use the right key to scroll to *SET* and then press the Center button.

3. Place the white sheet of paper (or gray card) in the same light that will illuminate your subject when you take your planned photo.

4. Look through the viewfinder and point the lens so the central area of the frame (within the circle etched on the viewing screen) is filled with your white or gray target. Be careful not to cast a shadow over your target. The white or gray sheet does not need to be in focus.

5. Press the shutter button all the way down. The camera will take a photo of your white or gray target. When it does so, it also calibrates the WB system. An image of your target will now appear in the LCD monitor with the words "Custom white balance" above it.

6. If the image looks neutral white or gray—depending on the target you used—the calibration process has been successful. If not, turn the camera off and back on. Recalibrate the system.

7. When you're satisfied, press the Center button to confirm this Custom WB selection. The camera will memorize this white balance setting and return to normal operation in all other respects. You can now begin taking photos under the specific lighting condition and the images should exhibit correct white balance.

On rare occasions, you'll get a "Custom WB error" message in the LCD monitor indicating that the system cannot calibrate under the existing conditions. This is most likely to occur when a white target is illuminated by extremely bright light or if you used flash for the calibration process. In that case, try again after pushing the flash back into the down position. If you again get an error message in extremely bright light, you will need to calibrate using a gray card because it reflects less light; the calibration process should then be successful.

Note: The α100 saves the last custom WB setting even when the camera is turned off. If you repeatedly shoot in the same sports arena, for example, you can recall the setting simply by selecting Custom white balance and scrolling to the Recall option listed in the LCD monitor. Press the Center button to confirm your selection. However, since the system only retains the last calibration, be sure to recalibrate if you shoot in different light.

Color Temperature 5500K

This option allows you to set a specific Kelvin color temperature for white balance purposes. It is intended for photographers who use a color temperature meter or shoot under lighting with a known color temperature, or who follow the manufacturer's recommendations for certain types of lighting. If you aren't using these methods, the camera's other white balance options will be more useful.

Scroll down to the third item in the WB menu in the LCD to Color Temperature **5500K** , then scroll to the right. Two new displays will appear in the LCD monitor: a numeral with K for Kelvin, and the magenta/green compensation scale that runs from M9 to G9. Initially, ignore the scale and set a desired color temperature using the up/down keys.

The magenta/green compensation feature allows you to further adjust the white balance toward either magenta or green as if you were using filters over the lens, as in traditional film photography. (This feature is most helpful for fine tuning white balance for fluorescent bulbs, which tend to produce a green color cast.) Scroll right to the scale and then select the level of compensation using the up/down keys.

White Balance Bracketing
When white balance bracketing is active, the camera generates three image files of a scene, each at a slightly different white balance setting. It's available with all of the WB options when shooting JPEGs. (It is not necessary with RAW since you can easily change the color temperature when processing your ARW files.

Access this feature by pressing the drive button ⟳/⧠ (on top right of camera). A screen with six icons will appear on the LCD monitor. Using the Controller keys or the Control dial, scroll to the last option, *Lo WB*, to set a slight variance in color temperature. A second option is also available, *Hi WB*, for a greater variance in color temperature. You can select either using the up/down keys. After making your selection, press the Center button to confirm your choice.

When you take a single shot, the camera's processing system automatically generates the original image file plus two copies, each with a slightly different white balance adjustment. (Only the last of the three images will be displayed on the LCD monitor, but you can view all three in the camera's Playback mode.) One duplicate image will be slightly warmer (red/yellow) while the other will be slightly cooler (blue). The difference will be most obvious if you selected the *Hi WB* bracketing option.

With colorful subjects, try experimenting with the various color modes, such as Vivid and Landscape. They provide more vibrant images, with richer colors, higher sharpness, and snappier contrast.

In my experience, this feature is most appropriate when using **AWB** or one of the preset white balance options. It increases the odds of getting an image with the most pleasing color. This feature has some disadvantages: it's available only with Single frame advance; the extra two files consume more space on a memory card; and though it takes less than a second, the extra processing time may cause you to miss a fleeting gesture in candid picture taking.

Color Spaces and Modes

Digital cameras render color based on combinations of red, blue, and green and in terms of hue, saturation, and brightness. The various systems that define these colors are called color spaces. Color spaces were invented with different biases based largely on how images will be created or viewed. Two

color spaces are common in digital imaging: sRGB and Adobe RGB. sRGB is the default color space used by the α100 and is ideal for on-screen viewing and Internet use.

Note: Color mode selection is available only when using the α100's M, S, A or P exposure mode. In the fully automatic modes, the camera makes such settings. For example, with subject-specific scene modes (such as Portrait, Landscape, or Sunset), the camera automatically selects the most appropriate color mode option for the subject type.

When using the M, S, A or P exposure modes, you can select from a variety of color modes, choosing one that will produce the effects that you consider most appropriate for any scene. To access these, rotate the Function dial to DEC (an abbreviation for Digital Effects Control) and press the Fn button. A new screen will appear on the LCD monitor providing two distinct options: a choice of various color modes at the top and a scale below for adjusting Contrast, Color Saturation and Sharpness. For now, stick with color mode selection options at the top.

Note: All of the options except Adobe RGB cause the camera to use the sRGB color mode. This color space is also the right choice if you plan to print directly from the camera or memory card using a photo printer that does not support the Adobe RGB color space (see below) in direct printing. (Check the printer's instruction manual for specifics.)

Most commercial volume printing firms also use sRGB images, so this option is fine for images that you take or send to a high-volume printing lab (photofinishers, on-line printing services, etc.). Be aware that most of these firms usually convert any Adobe RGB images you send to sRGB before making prints. On the other hand, labs offering professional quality custom printing often use the Adobe RGB color space, taking advantage of its wider color gamut.

Use the left/right keys to scroll through the various options. Press the Center button to confirm your selection.

The different options are:

Standard: Employing the sRGB color space, this mode produces JPEGs with rich, faithful colors, moderately high sharpness and contrast.

Vivid: This generates images with "deep and vivid" colors most appropriate with landscapes where a particularly bold color rendition is desirable. It is less suitable for portraits because skin tones will not appear natural.

Portrait: This mode is optimized for the reproduction of skin tones. In-camera contrast, sharpness, and color saturation are slightly reduced for a softer, more flattering effect with natural (not overly rich) colors.

Landscape: This mode reproduces outdoor scenes with higher than average contrast, color saturation, and sharpness. Similar to Vivid, it produces "punchier" images. Especially in reds, color saturation is so high that there can be loss of fine detail (for example in flower petals).

Sunset: Optimized for landscapes at dusk and dawn, this produces a yellow color cast when used in daytime shooting. Contrast and color saturation are automatically increased slightly to produce a sunrise or sunset photo with a warm rich glow as well as high color richness.

Night View: For night scenery without flash, this choice sets slightly high contrast. In low light I found this mode similar to Standard, although the former exhibits slightly higher contrast and deeper color tones.

Black & White (B&W): Images are generated monochrome. The tones are neutral and the overall effect is suitable for making prints without adjustments in image-processing software. However, serious black-and-white photographers will want to adjust Levels and other controls in their imaging software to produce the exact desired effect.

Adobe RGB: The camera generates images using the Adobe RGB color space, which defines a wider color gamut (recording range) than sRGB. This is useful for making inkjet prints. However, when viewed on a computer monitor, Adobe RGB exhibits less rich colors than sRGB.

Note: Many image-processing software programs are not compatible with Adobe RGB color space, though the Sony and Adobe brand software programs are compatible. (In Adobe software, be sure to select Adobe RGB in the Color Settings menu item.) Programs that are incompatible with Adobe RGB will convert the images to the standard sRGB color space, produce an "incompatible color space" error message, or generate an inaccurate display of the colors on a computer monitor and in inkjet prints.

If your favorite imaging software is not Adobe RGB compatible, simply avoid selecting this option when using the α100. All of the other in-camera color options employ the sRGB color space.

Optimizing Images In-Camera (DEC)

In-camera image optimization is particularly useful if you shoot JPEGs and print directly from the camera or a memory card. If you fall into this category, you may wish to consider the Digital Effects Control (DEC) feature of the α100. It allows you to alter the level of contrast, sharpness, and color saturation from very low to very high when using the camera's M, S, A, or P exposure modes. (There's no need for this feature if shooting in RAW format because the images can be adjusted in the converter software before conversion to another format.)

Before adjusting any of these three attributes, select one of the color modes (use the Function dial and Fn button as previously described). In the LCD display, note the three scales that appear, one for each attribute. The default for these is 0, and they can be adjusted within a range from –2

to +2 using the left/right keys. After you make any change, press the Center button to confirm your selection.

Contrast ◑

Without internal adjustment, the α100 produces images with snappy contrast in Standard color mode. Higher or lower contrast is used in some other color modes as mentioned previously.

To reduce contrast in harsh lighting conditions or to create flattering portraits that benefit from a soft look, you may want to adjust the contrast to –1 or to –2. In flat light, such as an overcast day, you might want to try a +1 level for more separation of light to dark elements, but think twice about selecting a higher contrast level for any other type of lighting. Low contrast is easy to fix in image-processing software, but excessive contrast can be difficult to moderate. In fact, you may want to permanently set a –1 level if you plan to enhance your photos in image-processing software.

Color Saturation ⊕

At its default setting in Standard color mode, the α100 produces images with rich, vibrant color saturation appropriate for most subjects. (When using a polarizing filter over the lens, color saturation can be especially vivid.) However, if you find the colors to be excessively rich (in any color mode), set a minus factor when shooting JPEGs. Decreased saturation may be useful in portrait photography where a muted color rendition is often more pleasing.

I find that a –1 saturation level (in Standard or Adobe RGB color mode) produces color that is preferable for the majority of subjects, but this is a subjective judgment. If you plan to extensively manipulate your JPEG photos in image-processing software, you'll probably want to start with a –1 or –2 level in-camera. Think twice about selecting a high saturation level; excessive color saturation can lead to loss of detail; that problem can be very difficult to correct later in the computer.

Sharpness 🔲
The camera produces sharp images in Standard color mode and even higher in some other color modes. You can increase sharpening to +1, but I suggest you do so only if you do not plan to use any sharpening filters in image-processing software in the computer. In my view, the +2 level produces excessive sharpening, which can be difficult or impossible to correct.

Some post-processing experts prefer to select the lowest in-camera sharpening level available (–2), using special sharpening techniques in image-processing software to achieve exactly the sharpness level that's ideal for any specific image. Frankly, I find that a -1 setting works well enough to produce sharp—but not artificially sharp—images. Before making a print, I apply sharpening using Unsharp Mask in Photoshop or Elements, selecting exactly the amount that is appropriate for the subject and the print size.

D-Range Optimizer (DRO)

This feature is not currently available with any other DSLR. D-Range Optimizer is provided by the camera's BIONZ processor and causes the camera to apply extra processing to your image files. When not set to *off*, this function offers two modes: *Standard (D-R)* and *Advanced (D-R+)*.

Off: The camera's processor does not take extra steps to correct brightness or contrast.

Standard D-R : The basic mode, its primary purpose is to recover shadow detail in scenes with a lot of contrast. For example the scene may include a very bright sky and a darker landscape. Standard will lighten the shadow areas for a more pleasing overall exposure. The extra processing takes very little time and operation will not slow down.

Advanced D-R+ : In this more sophisticated mode, the camera analyzes 1200 individual segments of the scene and

adjusts brightness only in specific areas of the image. Then the processor will lighten shadow areas and darken very bright areas in order to bring out detail in both for a more pleasing overall effect. This extra processing does take some time, so the camera's framing rate will not be the full three frames per second. In other respects, you won't likely notice any slowdown; the α100 will still usually be ready to take a few shots, even while it is recording previous images to the memory card.

When the camera is set to AUTO or any of the α100's scene exposure modes, it automatically applies **D·R** unless you select Off or **D·R+** . The camera will return to the Standard default in these exposure modes any time you power off and back on again. Note, however, DRO is not automatically activated in P, A, or S exposure modes; you have to select *Standard* or *Advanced* if you want to optimize in these exposure modes.

To activate your choice of DRO, turn the Function dial to D-R and press the Fn button. Then use the Control dial or Controller keys to scroll to your selection, pressing the Center button to confirm.

D-Range Optimizer will not produce any effect when you are shooting RAW (or RAW&JPEG) files, or when the exposure mode is set to Manual, or when either Spot or Center weighted metering is in use. That's fine, because this function is really a problem-solving tool that is unnecessary for many photos.

The result of DRO can vary from subtle to obvious. Try experimenting with both of its modes to determine whether you appreciate the effect that each produces or whether you prefer to make the necessary exposure/contrast changes in image-processing software. Once you have a better understanding of the effect that each mode provides, you'll know when to select one of the modes or when to leave the feature turned off.

Digital noise increases at higher ISO settings (in this case, ISO 1600) and is often evident in dark areas, such as the shadows in the porch of this house. © Kevin Kopp

Noise Reduction

Digital images made using long exposures can exhibit noticeable digital noise even when low ISO settings are used. The effect is similar to the grain we see in prints made with high-speed films, but the specks are more colorful. The "noise pattern" is most visible in mid-tone areas or in dark areas that are lightened with image-processing software. Although the α100 automatically applies noise reduction during standard processing, the camera includes a feature specifically designed for additional noise reduction during exposures of one second or longer. When this feature is set to *On*, additional in-camera processing minimizes the "grainy" effect during long exposures (both the sharpness and the color of the specks are moderated).

Noise can become even more prominent when you try to brighten dark areas with your image-processing program.

To activate this feature, press the MENU button and use the Controller keys to select 📷1 ; scroll down to *Noise reductn.* Select *On* and confirm it by pressing the Center button.

Note: Be aware that noise reduction will not be active if the camera is set in Continuous Advance or Continuous bracketing drive.

If you often make long exposures, as in night photography, you may appreciate this feature. However, there are two primary drawbacks:

1. The entire image becomes slightly softer than it would be without the extra noise reduction processing. That can be corrected to a degree with the in-camera control for increasing sharpness or, preferably, in a computer using image-processing software.

2. There is a delay after you take a shot of up to 30 seconds while the noise reduction is applied. During this time the camera is not operable, which can be quite frustrating.

The Menus

The α100 offers an extensive list of menu options, though fewer than some other cameras do. That's because many features that require menu access with other cameras are accessible by using the Function dial and pressing the Fn button. That design reduces the amount of time needed to find a commonly used function.

To access the α100's electronic menus, press the MENU button (located on back of camera to left of LCD monitor). Always scroll to the menu item you want to access by using the left/right and up/down keys on the Controller. Enter your selections using the Center button (marked AF) in the middle of the controller. When you reach a menu page where the list of items appear dark, press the Center to illuminate that page (necessary only with certain pages).

There are four different menus, each with own set of tabs (or individual screens) as listed here:

- Recording Menu 1 ◘1
- Recording Menu 2 ◘2

- Playback Menu 1 ▣1
- Playback Menu 2 ▣2

- Custom Menu 1 ✿1
- Custom Menu 2 ✿2

- Setup Menu 1 ✎1
- Setup Menu 2 ✎2
- Setup Menu 3 ✎3

↪ *For best results, set your α100 to use the highest image size (resolution) and lowest compression rate (quality).*

79

The maximum number of pixels are recorded when you shoot JPEGs using the largest resolution (L:10M). This is an advantage if you want to crop your pictures (see photo on next page) or make large prints.

The Recording Menus ♠

These let you define image parameters such as size, quality, and format. They are also used to control flash, noise reduction, instant playback, etc. The Recording section consists of two distinct menus: Recording Menu 1 and Recording Menu 2.

♠1 Recording Menu 1

Press the MENU button and ♠1 will appear highlighted. Scroll down to highlight one of the five main functions listed below, then scroll right to see the further options described. Finally, scroll up/down to make your selection and press the Center button to confirm.

Image size: For JPEGs, select *L:10M* for 10 megapixel resolution (Large or 3872 x 2592 pixels), *M:5.6M* for 5 megapixel resolution (Medium or 2256 x 1496 pixels), or *S:2.5M* for

This crop emphasizes the people in the photo and retains enough digital information to make a print of at least 3 x 4 inches (7.6 x 10 cm).

2.5 megapixel resolution (Small or 1920 x 1280 pixels). These sizes are discussed in detail on pages 55-56. Press the Center button not only to confirm your selection, but also to return to the menu screen.

Quality: This feature allows you to record in *RAW, RAW & JPEG,* or to select strictly JPEG with either of two different quality levels: *Fine* (lowest compression) or *Standard* (slightly higher compression). See pages 56-57 for description of how to use these settings.

Note: When you select *RAW* or *RAW & JPEG,* the camera automatically sets image size to 10 MP. It also blacks out the *Image size* option so it cannot be accessed. I often use RAW format because of the image-enhancing options available in conversion software. Shooting a JPEG file at the same time can be useful if you own image-browser software that does not recognize the Sony ARW format files; at least you can view the JPEG file.

Instant Playback: This sets the length of time an image is displayed on the LCD monitor immediately after an exposure is made. Select *2 sec.*, *5 sec.*, *10 sec.*, or *Off*. Use 2 sec. to conserve battery power. Select *10 sec.* if you want to analyze your pictures before deciding whether to keep or delete. Use *5 sec.* as middle ground. Remember, you can examine any image for longer periods of time by using the camera's Playback mode.

Noise Reduction: This setting activates the digital noise reduction feature for exposures longer than 1 second. You select either *On* or *Off*.

Eye-Start AF: The α100 automatically recognizes when the camera is in the shooting position, using sensors under the eyepiece. It automatically activates autofocus and light metering when it detects your eye. Although *Yes* is the default setting, you can choose to turn the Eye-Start system *Off*.

To conserve battery power, you might decide to turn Eye-Start off, preventing the camera from activating any time an object is detected near the viewfinder. For example, it may start up when you're carrying the camera on a neck strap against your chest.

◘2 Recording Menu 2

Press the MENU button and scroll with the right Controller key to highlight ◘2 . Then scroll down from Recording Menu 2 to highlight your desired menu function. Next scroll right to see further options. Finally, scroll up/down to make your selection, pressing the Center button to confirm your choice.

Red-Eye: This feature activates red-eye reduction when the flash is used. It will rapidly fire several bright bursts before the actual flash exposure. Select either *On* or *Off* (default).

Flash Control: The default setting is *ADI flash*, for Advanced Distance Integration, the more sophisticated option. It is only available when using Sony lenses, Carl Zeiss Alpha lenses, or D-series Konica Minolta Maxxum/Dynax lenses. It will operate with the built-in flash, with Sony HV series flash units, and with Maxxum/Dynax D-series flash units.

When a compatible lens and flash are used, the camera's flash exposure metering system considers data about subject distance in its calculation process. If you are using other lenses or an older Konica Minolta flash unit, the camera will automatically switch to Pre-flash TTL metering to compensate for the lack of distance information.

You can also select the *Pre-flash TTL* option, described in more detail in the chapter on flash (see page 156), but I see no reason for doing so in normal shooting. Sony does recommend that you use *Pre-flash TTL* instead of *ADI flash* in certain specific situations, such as when using flash with a polarizer on you lens or a wide-angle diffuser attached to the flash unit.

Flash Default: Use this selection to choose between two different flash modes to set as your default.

In the standard *Autoflash* setting, the camera fires an activated built-in or accessory flash whenever it is necessary due to low light or backlighting.

If you scroll down to select the *Fill-flash* option, flash will fire for every shot in all of the exposure modes.

Autoflash vs. Fill-Flash

Though the flash mode default is selected in Recording Menu 2, you can use the Function dial and Fn button to change flash modes. Since there are two different ways to gain access to flash modes, setting the desired mode can become confusing, so consider the following explanation.

The flash mode that can be used depends on the camera exposure mode that you have set. Remember that in *Autoflash* mode, when either the built-in flash or an accessory unit is activated, the flash fires only if the camera determines that the scene is dark or if the subject is backlit. In *Fill-flash* mode, the flash fires for every exposure if the built-in flash is pulled up or an accessory flash unit is on.

If the camera's exposure mode is set for AUTO, P, or one of the fully automatic scene modes (Landscape, Portrait, etc.), you can use either *Autoflash* or *Fill-flash* (selecting your choice with the Function dial and Fn button). You can only use *Fill-flash* with the A, S, or M exposure modes.

With AUTO, P, or one of the scene modes, the camera's default flash setting is *Autoflash*. This means that the α100 will revert to the *Autoflash* mode any time you switch from the current exposure mode to any fully automatic exposure mode, or any time the camera is turned off and then turned on again. If you do not want the flash mode to revert to *Autoflash*, you can set *Fill-flash* as the camera's flash default mode in Recording Menu 2. The flash mode can still be changed using the Function dial and Fn button.

When the camera is set to the A, S, or M exposure modes, you cannot select *Autoflash* as the flash mode. When shooting in any of those exposure modes, *Fill-flash* will be set automatically and if the flash is activated it will fire every time a picture is taken. Even if you have set *Autoflash* as the flash default in Recording Menu 2, it will not be selected with A, S, or M exposure modes.

84

Frankly, I suggest leaving the flash default at *Autoflash* in the Recording Menu. When you use AUTO, P, or one of the automatic scene modes, the flash will only fire if the camera determines it is necessary; this makes sense for fully automatic shooting. If you occasionally want the flash to fire for every shot in AUTO or one of the scene modes, you can always select *Fill-flash* with the Function dial and Fn button. The default mode set in Recording Menu 2 has no effect on using flash with the camera's A, S, or M exposure modes. The *Fill-flash* mode is always used with these exposure modes. When you activate the flash, it will fire every time. (Refer to the Flash chapter, pages 157-161, for more details about using flash in the camera's various exposure modes.

Bracket order: This menu item lets you set the order of the exposure compensation sequence in exposure bracketing. The first option is *0, –, +*. Your alternative choice is *–, 0,+*. Your selection will be dictated by personal preference.

Reset: This control returns many of the camera's recording functions to the factory-set defaults. It's useful after you have been experimenting with some of the camera's many features.

The features that reset to default are: Exposure Compensation to *0*, Flash Compensation to 0, AF Area to Wide AF area, AF mode to *AF-A* (automatic switching between Single-shot and Continuous AF), Metering mode to *MultiSegment* (evaluative honeycomb pattern), Drive mode to *Single-frame advance*, Preset White Balance to *Daylight* with *0* compensation; Color Temperature to *5500K* with *0* Green/Magenta adjustment, Color mode to *Standard* (sRGB), Digital Effects Control to *0*, Flash mode to *Autoflash* or *Fill-flash* (depending on which of the two default settings was most recently used), and Flash control to *ADI*.

▶ The Playback Menus

There are two Playback menus that offer several useful options for reviewing and managing images you have recorded to the memory card.

To access the Playback menus, press the MENU button. Scroll right to ▶ and press the Center button to illuminate (activate) the menu. Scroll to select ▶1 or ▶2 . For quicker access to the Playback menus, press the Playback button and then the MENU button.

▶1 Playback Menu 1
This section includes several choices for image review, along with their respective sub-choices. It also includes the option to format your memory card.

Scroll down from ▶1 to highlight menu function from the choices described below. Then scroll right to see further options. Finally, scroll up/down to make your selection, pressing the Center button to confirm your choice.

🗑 **Delete** : This setting will permanently erase images from your card, either images that you specify (mark), or all images on the card. Caution is urged when you use this option because images deleted cannot normally be recovered.

The default is *MarkedImages*, which lets you select specific images to be deleted. This option displays images on your memory card as thumbnails. Scroll through them using the left/right Controller keys and select frames for deletion with the Controller's up key. If you accidentally select a frame for deletion, you can deselect it with the down key. Press the Center button to display a confirmation screen, then select *Yes* or *No* and press the Center again button to complete the operation. (Cancel this process at any time before completion by pressing the MENU button.)

The option for *All images* deletes all unprotected frames on the memory card. Press the Center button to display a confirmation screen, then select *Yes* or *No* and again press the Center button to complete the operation. (Cancel this process at any time before completion by pressing the MENU button.) Remember that this permanently deletes all images, except those that are protected.

Format: This item formats the memory card, permanently erasing all data. Even protected images are deleted. When *Format* is highlighted, press the Center button and choose Yes or No from the confirmation screen. Verify your choice by again pressing the Center button, and a final screen will confirm the formatting activity.

Never remove a memory card when formatting is under-way; it could damage your card. I recommend reformatting the card every time after you download images to your computer's hard drive or other backup system to keep the card performing at its optimum level.

⊙ **Protect :** This allows you to mark images so that they cannot be accidentally deleted. Only reformatting the card will delete protected images. Use the Controller keys to first scroll right and then up/down to select from the choices described below. Press the Center button to enter your selection:

As in the Delete page, *MarkedImages* is the default for the Protect page. It permits you to select specific images for pro-tection. Scroll through the thumbnails using the left/right Controller keys and select protected by pressing the up key. The ⊙ icon appears on the protected thumbnails. If you accidentally select a frame for protection, you can deselect it with the down key. Press the Center button to display a confirmation screen, then select *Yes* or *No* and press the Center button to complete the operation. Cancel this process at any time before completion by pressing the MENU button.

The choice for *All Images* allows you to protect all of the images on the memory card. The *Cancel All* option removes protection from all images on the card.

Index Format: This is the last item in Playback Menu 1 and it allows you to designate the number of thumbnails that should be displayed at one time on the LCD monitor during the marking process. Scroll to the right to select File Browser to display six images on the screen at one time (a practical setting) or select option for 4, 9, or 16 images as the pertinent number of thumbnails to be displayed at one time. The more image thumbnails that are displayed, the smaller each one will be.

▶2 Playback Menu 2
This menu contains items less frequently used but ones that are still valuable to know about.

Scroll down from ▶2 to highlight your desired menu function. Next scroll right to see further options. Finally, scroll up/down to make your selection, pressing the Center button to confirm your choice.

Slide show: When you select *Enter* and press the Center button, the camera will play back all the images on the card at a rate of one image every five seconds. To pause and restart the slide show, press the Center button. To move ahead or go back, press the left/right Controller keys. To cancel the Slide show, press the down.

DPOF set: This option designates files on your memory card for direct printing using a DPOF (Digital Print Order Format) compatible printer direct from the memory card in your camera. (Downloading into a computer is not necessary). The three options are selected in a similar way as the same options in the *Delete* and *Protect* menus:

MarkedImages lets you choose one or more files for DPOF. Only JPEGs can be marked for printing. Scroll through the thumbnails and enter those for DPOF by using the up key. Press the up key again for any selected thumbnail to increase the number of prints (up to nine). A printer icon with the number of prints next to it indicates the frames marked for DPOF. Use the down key if you want to decrease the number of prints: zero deselects the frame entirely. Press the Center button to confirm your selections and return the Playback 2 menu screen.

All on card selects all images on your memory card for DPOF. Press the Center button to confirm your selection.

Date imprint: When *On*, the date will be printed on the photo when DPOF printing is used with compatible DPOF compliant printers. The date is not printed on the actual JPEG image file, only on the print.

Index print: The *On* option creates an index of thumbnail prints for all images in a folder for printing with a DPOF compliant printer. The number of images printed per sheet varies from printer to printer. Highlight Off to cancel the index print. Press the Center button to confirm your selection.

Cancel print: Use this option to remove the DPOF mark from all images that were previously marked. This does not delete images, it simply ensures that they are no longer marked for DPOF printing. Select *Enter* and then *Yes* when asked to "Cancel all?" Press the Center button to confirm your selection.

☼ The Custom Menus

The α100 provides Custom options so you can tailor camera settings to your own preferences. Most camera owners do not take full advantage of the Custom menus, but some of these features can be handy. There are two Custom menus in the α100.

☼1 Custom Menu 1
The options in this menu are preferences more than necessities, and your α100 will work fine if these functions are left in their default settings. It is a good idea to use your camera for a couple of months and really get to know the basics before plunging into most of these. Nonetheless, here is a brief explanation of each item.

Scroll down from ☼1 to highlight your desired menu function. Next scroll right to see further options. Finally, scroll up/down to make your selection, pressing the Center button to confirm your choice.

Priority setup: The first item, *AF*, is the default setting. It ensures the camera will not take a photo unless focus has been confirmed when using Single-shot AF. You can also select *Release*, which allows the camera to fire whether focus is confirmed in Single-shot AF mode or not. (In Continous AF, focus is never locked; focus shifts continuously as your subject moves.) Some photographers may want to use this option for taking candid pictures in low light, preferring to get a slightly out-of-focus image to no image at all. An icon for RP (Release Priority) displays in the LCD monitor when this is selected. Remember to reset *Priority setup* to *AF* afterwards, though.

FocusHoldButt: A select number of Maxxum/Dynax and Sony lenses have a button used for locking focus when the camera is set to focus continuously. If you select the *Focus hold* option, the button will behave as expected. However, if you select the *D.O.F.preview* option, the button on pertinent lenses will act as a depth-of-field preview button. This is not necessary since the α100 has its own depth-of-field preview button (discussed on page 125).

AEL button: This controls the function of the camera's AE lock button. (AE lock is a feature used to lock an exposure value before recomposing, as discussed on page 139.) Four distinct options are available by scrolling to the right from the *AEL button* menu item:

AE hold is the default setting. The AE lock (AEL) button is active only while you depress it. If you do not maintain pressure on the AEL button, the exposure value will not remain locked.

AE toggle provides an on/off effect. Press the AEL button once and exposure value is locked. It remains locked; there is no need to keep it depressed while you recompose a scene. To turn AE lock off, press the button again. *AE toggle* might be useful in landscape photography to lock the exposure values while you recompose the shot. However, it can also lead to serious exposure errors if you forget that *AE toggle* has been set and do not turn AE lock off when switching to a different subject, or when the light level changes.

Spot AE hold activates spot metering whenever the AEL button is pressed and held down. (This occurs regardless of the light metering pattern you selected using the metering mode item on the Function dial.)

Spot AE toggle provides the same function as the previous option but does not require you to keep the AEL button depressed to keep the exposure value locked. When you're ready to turn Spot AE lock off, press the button again.

With either Spot AE option activated, you must remember that pressing the AE lock button causes the camera to meter only the light in the center of the frame. If you forget that Spot AE is in effect and press the AEL button, you may inadvertently lock-in over or under exposure. If you want to use spot metering, another method is to select that option with the Function dial and Fn button (for more information on spot metering see page 133).

Ctrl dial set: This changes the function of the Control dial, but only in the camera's P (Program) and M (Manual) exposure modes. The default setting is *Shutter speed*, allowing you to select your desired shutter speed in either exposure mode with the Control dial. (In P mode, the camera will then set an appropriate aperture.) If you want to select an aperture (f/stop) instead in M mode, you must press and hold the exposure compensation button while rotating the Control dial.

The *Aperture* option changes the role of the Control dial in P and M modes to control the f/stop. Use it to select a desired aperture in either mode. (In P mode the camera will automatically set the appropriate shutter speed.) If you want to select a shutter speed while in M mode, you must press and hold the exposure compensation button while rotating the control dial.

Exp. comp. set: This applies when the flash is used. The default setting is *Ambient&flash.* letting you set the camera's exposure compensation button (+/- on back of camera to right of viewfinder) to affect both the ambient light and the flash exposure. That's useful unless you specifically want to control the ambient light compensation and flash exposure compensation separately. In that case, select the *Ambient only* option. When you then use exposure compensation, only the ambient light exposure will be changed; the flash intensity will not change.

Note: You can increase or decrease the flash exposure, without affecting the ambient-light exposure, using flash exposure compensation, available through the Function dial and Fn button.

Shooting in a big indoor setting presents lighting challenges. Here, I adjusted the flash exposure compensation to +1 in order to prevent underexposure.

AF illuminator: The default setting for this is *On*. When the built-in flash is up, it will fire several short bursts in low light to assist the AF system in acquiring focus. You can turn this feature *Off* if your friends find it annoying while taking their pictures. The AF system should still be reliable except in very dark conditions.

✿2 Custom Menu 2
Six additional items are available for further customizing the camera.

Shutter lock: There are two shutter lock options in ✿2. The first refers to memory cards. The option for *On: no card* (default) prevents the camera from firing unless a memory card has been loaded. This way you can't inadvertently start taking pictures without a card. The *Off: no card* choice permits the camera to fire even if no card is loaded (not recommended).

Shutter lock: This second listing refers to lenses. When *On: no lens* (default) is selected, the camera cannot shoot unless a compatible lens is mounted. Because the camera's reflex mirror will not be raised when no lens is mounted, the CCD sensor remains protected from dust and other elements. However, you can also select *Off: no lens* to trip the shutter even if you have not mounted a compatible lens. This is necessary only when the α100 is attached to a telescope or microscope using a special adapter.

AF area setup: This allows you to change the time that the autofocus points are illuminated on the viewing screen for focus confirmation. Select *0.3s display* for a brief indication, *0.6s display* for longer. You can also select *Display off* so the active focus point(s) will not illuminate on the viewing screen. Frankly, the focus point illumination feature is very useful for confirming what part of a scene will be in sharpest focus; select *Display off* only if you find it particularly distracting.

Monitor disp.: The *Automatic* setting (default) turns the LCD monitor off automatically when the viewfinder is used. (Two proximity sensors detect your eye at the viewfinder.) The default setting is both logical and useful for conserving battery power. You can also select *Manual*, causing the LCD monitor to be on (with data display or image playback) even when you're looking through the viewfinder to take another shot. In that case, use the display button |◻| to turn off the LCD monitor.

Rec. display: Sets the format for recording data display. When set to *Auto rotate* (default), the recording data in the LCD will shift between horizontal display and vertical display as the shooting orientation of the camera is shifted respectively. Select *Horizontal* to keep the recording data display fixed in horizontal format.

Play display: This determines image orientation during playback. *Auto rotate* (default) displays a vertical image upright on the horizontal LCD monitor (which makes the image smaller) as well as on a computer monitor when using either

of the Sony software programs bundled with the camera. If you prefer to view such vertical images in a horizontal orientation, in a larger size using the entire LCD monitor, select *Man. rotate* instead.

✦ The Setup Menus

The final menu section, consisting of three distinct screens, controls various aspects of camera operation.

To access these functions, press the MENU button. Then scroll to ✦ and press the Center button to activate your selection.

✦1 Setup Menu 1

It's a good idea to become familiar with the six items in this menu because you will not only want to set them when you first get your camera, but you may also need to adjust them from time to time.

Scroll down from ✦1 to highlight your desired item, then scroll right to see further options. Next scroll up/down to make your selection. Press the Center button to confirm your choice.

LCD brightness: Select *Enter* to activate a slider that makes the LCD monitor darker or brighter. The right/left Controller keys adjust brightness from *Low–* to *+High*. Confirm slider choice by pressing the Center button.

The higher you set monitor brightness, the easier it is to see data or images on the LCD monitor in bright conditions. However, by setting the brightness higher or lower than the default, you will not be able to correctly evaluate exposure (actual image brightness) on the LCD monitor.

Transfer mode: The default setting is *Data storage*, which allows a computer to recognize the camera as a USB mass storage device. That is useful if you will be attaching the

By setting the Transfer mode to PTP in Setup Menu 1, you can print photos directly from your α100 to a PictBridge compatible printer, bypassing the need to first download image files into a computer.

camera directly to a computer via a USB cable in order to download your images. Select *PTP* for making prints directly from the camera using a PictBridge compatible printer. This will require connecting the α100 to the printer using the USB cable.

Video output: You must select a TV/broadcast standard if you want to playback images on a TV set. Two options are available for video system compatibility: *NTSC* (North American standard also used in Japan) and *PAL* (Europe and many other countries). Make enquiries as to which standard to use in your geographic area.

Audio signals: *On* (default) causes the camera to beep when focus is confirmed in Autofocus mode. Select *Off* to disable this audio feature.

Language: Set the operating language. English is the default.

Date/Time set: Set the date and time when you first get your α100, and change them when needed. A screen will display YYYY/MM/DD. Use the up/down keys to adjust the date and time while scrolling from field to field with the left/right keys. Enter the complete setting with the Center button. This data will not be printed on your images. However, it will be recorded by the camera for every image and can later be accessed with image-processing software.

⚙2 Setup Menu 2

This section provides options for naming file folders and creating new file folders to be used for storing images on the memory card. If you find all of this to be confusing, simply use the default settings.

Scroll down from ⚙2 to highlight your desired item, then scroll right to see further options. Next scroll up/down to make your selection. Press the Center button to confirm your choice.

File # memory: This menu function manages how the camera will label images in different folders on the memory card. The default setting is *On*. A new image file will have a number that is one greater than the previously saved file, even if it is saved to a different folder. When *Off* is selected, a new file will be labeled with a number that is one greater than the last image saved in that particular folder.

Reset: This feature resets the image file numbering to 0001. As you shoot subsequent photos, the number will increase by one for each shot.

Folder name: This option is used to determine which of two formats are assigned to name folders on the memory card. Each consists of eight characters. *Std. form* (default) creates a label such as 100MSDCF. You may prefer to select *Date form*, a format that follows a sequence such as 101 6 11 28, indicating a folder created on November 28, 2006. If you

select the *Date form* option, a new folder will be created on each day when you make an image with the camera. All images made that day will be saved in that folder.

Select folder: This item allows you to specify the folder to which images should be saved. When you select this item, you'll see a list of current file folders that have been created. Specify the one that you want to use to store the next set of images that you will shoot.

New folder: Use this item to create new folders on your memory card. From *Select folder*, scroll down to highlight *New folder*, then right to highlight *Enter*. Press the Center button to create a new folder that will use the Folder name format currently in use. Every time you create a new folder, the folder number increases automatically by one greater than the previous folder on the memory card.

𝄢 Setup Menu 3

The following items are available. Scroll down from 𝄢 to highlight your desired item, then scroll right to see further options. Next scroll up/down to make your selection. Press the Center button to confirm your choice.

LCD backlight: This determines a time period to keep the LCD monitor lit before the backlight goes off to conserve battery power. Press any camera button to restore the back-light. The default is *5 sec.*, but you can also choose *10 sec.*, *30 sec.*, or *1 min.* I suggest 10 seconds.

Power save: In order to conserve battery power, the camera automatically switches into "sleep mode" after a period of non-use. The default for this feature is *3 min.* You can also select *1 min.*, *5 min.*, *10 min.*, or *30 min.* Select one of the longer times if you want the camera always ready to shoot, but carry an extra battery because power consumption will be higher. The α100 can be quickly revived (in about one second) from sleep mode by pressing any camera button or by touching the shutter button.

You can revive the camera from sleep mode almost instantly when you touch any button, helpful for recording just the right moment.

MenuSec.Memory: This manages which menu screen will be displayed whenever your press the MENU button. Select *On* and the display will recall the last open menu. When set to *Off* (the default), pressing the MENU button will always call up ◘1 (or ▣1 if you are using the camera's Playback mode when you press the MENU button).

Delete conf.: Before considering the options in this item, it's important to understand the concept of delete confirmation. Whenever you are viewing an image (whether in instant review or in Playback mode), you can choose to delete that shot by pressing the 🗑 button. When you do so, the camera asks (in a note on the LCD monitor) "Delete this image?" The default answer is No. To delete, you must scroll to Yes and then press the Center button to start the deletion process. This minimizes the risk of inadvertent deletion.

However, when the *Delete conf.* menu item is set to *Yes*, the highlighted answer to the delete question becomes Yes, saving a scrolling step and therefore making the deletion process quicker. However, this choice also increases the odds of inadvertent deletion.

Clean CCD: Even though the α100 possesses an internal anti-dust feature, debris may still accumulate on your sensor from time to time. Use this menu item to gain access to the CCD sensor if you notice dust specks in your photos. A fully charged battery or the optional AC adapter is required. Proceed at your own risk! If you choose to use this process, follow these steps:

1. After selecting the Clean CCD item, scroll right to highlight *Enter* and press the Center button.

2. A note will then appear in the LCD monitor informing you to shut the camera off after the cleaning is finished.

3. Next, it will ask if you want to continue; select *Yes* if you are ready.

4. Remove the lens, or body cap.

5. The reflex mirror will flip up, revealing the CCD sensor.

6. Hold the camera facing downward and pump a blast of air from a large blower bulb toward the sensor; repeat this a couple of times to dislodge any dust particles. Use extreme care not to touch anything inside the camera's mirror box.

7. After cleaning is finished, turn the camera off and replace the lens, or body cap. The reflex mirror will return to its normal position.

A vibrating CCD mechanism removes dust and debris from the image sensor every time you turn your ∝100 off. However, you still need to use care when changing lenses so that dirt does not find its way to your sensor, especially in sandy or dusty environments.

Caution: *Proceed at your own risk. Improper cleaning may damage the CCD sensor and require expensive repair. Use extreme care when the CCD sensor is exposed. Use a large blower brush (sold by photo retailers) to produce a puff of air to blow away specks. Do not use a can of compressed air because propellant may be sprayed and that can damage the CCD. Sony does not recommend the use of sensor cleaning kits (swabs or brushes and liquids) that are marketed by third-party manufacturers. Contact a Sony authorized service center for professional cleaning if you have trouble removing dust.*

Reset default: This feature allows you to reset the camera to all of the default settings in each of the different menus sections simply by pressing *Yes*. Of course, if you are satisfied with the setting adjustments you have made, simply ignore this option.

Camera and Shooting Operations

Image Sharpness

Various factors contribute to the sharpness of an image. While focus, depth-of-field, and even use of flash play a role, proper handholding technique is also essential. If you don't use proper technique, camera movement may degrade image sharpness and your pictures will be disappointing. A good way to evaluate your technique is to review your photos. If the focused subject is not crisp, but another element in the scene is sharp, the problem is usually caused by an improperly focused image. However, if nothing in the photo is tack sharp, the cause is probably camera movement.

Long lenses, especially, are often heavy and difficult to hold steady. Just as telephotos magnify the subject, longer lenses magnify movement. A rule of thumb suggests that your shutter speed should approximates the reciprocal of the effective focal length of the lens in use to make sharp photos. For example, a 100mm equivalent lens would require a hand-held shutter speed of about 1/125 second, while 500mm equivalent would require at least 1/500 second. (When considering this, remember that due to the size of its sensor, the 35mm equivalent focal length of a lens on the α100 is the actual focal length multiplied by 1.5) If you cannot achieve a high enough shutter speed at your desired aperture setting, you can increase your ISO (but beware of digital noise at ISO 800 and especially at ISO 1600). If you want to shoot at long shutter speeds, use a tripod or other camera support.

◁ *This photo of Grand Central Terminal was shot at a handheld shutter speed of 1/40 second. I wouldn't have been able to get such good results without Sony's Super SteadyShot image stabilization system, which is built-into the α100 and works with any compatible lens.*

This before (above) and after (right) sequence illustrates the practical advantage offered by the Super SteadyShot (SSS) feature. The settings are the same for each of these handheld shots, including a shutter speed of 1/2 second, except this one was made without SSS.

Handholding Technique

Proper technique will maximize the odds of a sharp photo when handholding the camera. Hold the camera's grip in your right hand with your index finger on the shutter button. For horizontal (landscape format) pictures, cradle the lens and body in your left hand so that your fingers can comfortably operate the lens if necessary. For vertical (portrait format) shots, turn the camera so your right hand is on top and the opposite end of the camera is cradled in your left hand. With either format, keep your elbows in, pressed gently against your body for additional support. Spread you legs apart in a firm, but comfortable, stance. When you are ready to take a picture, exhale and roll your finger across the shutter button making sure to hold the camera level.

The Super SteadyShot (SSS) System

Sony has incorporated an improved version of Konica Minolta's anti-shake image stabilization technology into the α100. Unlike some other manufacturer's stabilization

With SSS switched on, camera shake is minimized, providing the ability to hand hold the camera at shutter speeds that are two stops less than comparable non-image-stabilized shooting situations.

systems, which work by shifting elements within a lens, Super SteadyShot shifts the sensor inside the camera body. This allows photographers to use image stabilization with virtually all Maxxum/Dynax lenses, all Sony lenses, and the Carl Zeiss Alpha series designed for the α100. It should also work with aftermarket brand lenses with the appropriate mount.

Turn the anti-shake feature on with the Super SteadyShot switch ((🖐)) (located on back of camera in lower right corner). The system consists of a sensor that detects motion and a mechanical device. When the in-camera sensor detects motion, a microcomputer analyzes data on focal length, aperture setting, and focusing distance and sends a signal to a motor which mechanically shifts the entire CCD sensor unit to compensate. The incoming light rays are refracted and the projected image is returned to the center of the frame, which produces a sharper image.

The SSS feature is designed primarily for hand-held use at shutter speeds shorter than 1/4 second. When the system is active, a ▪▪ll scale is displayed the right side of the viewfinder data panel. From one to five, more stairs means higher probability for camera shake. In bright light, with the system on, the scale may not appear because shutter speeds are high enough that no image stabilization is necessary.

No matter if the system is active or not, a second icon 🔛 will light in the viewfinder panel whenever the camera determines there is a likelihood of camera movement, based on the shutter speed and focal length.

You should practice using Super SteadyShot in low light. Point the camera and frame your subject. The more steps displayed in the scale, the greater the need for image stabilization. When all five steps in the SSS scale are displayed, maximum CCD shift is underway. In this case, the system may not be able to produce the sharpest image so consider using a faster shutter speed to make the shot. Or brace the camera against something solid for an additional bit of support to increase the odds of making a sharp photo.

SSS in Use
Sony indicates that the SSS system should allow you to handhold the camera at 2 to 3.5 shutter-speed steps longer than the rule of thumb (page 103) suggests. The system will also allow you to use longer shutter speeds to obtain smaller apertures in order to increase depth of field.

Take a conservative approach to be sure of getting photos without blurring from camera shake. Stay within two steps of your normal minimum handholdable shutter speed. Use even faster shutter speeds if practical, especially if maximum SteadyShot activity is denoted on the scale in the viewfinder. You may decide to exceed this recommendation, using even longer shutter speeds, especially if you're particularly steady when handholding any lens or if faced with an all or nothing shooting situation.

With large, heavy telephoto lenses, use a tripod. Sony recommends you disengage the SSS system whenever you use a tripod. When shooting from an unstable platform, such as a boat, activate the SSS system and use fast shutter speeds: at least 1/60 second with a 28mm focal length and at least 1/500 second at the 300mm end of a zoom lens. When using flash with the SSS system activated, the fastest possible sync speed is reduced from 1/160 sec. to 1/125 second. Finally, be aware that Super SteadyShot use increases power drain by roughly 30%, so take an extra battery if you plan on using it a lot during a very long day of shooting.

The Focusing System

The α100 has a sophisticated TTL phase-detection autofocus (AF) system to assure quick, accurate focusing in almost all picture-taking situations. It utilizes eight line-type CCD AF sensors plus a center cross-hatched sensor. The location of these sensors is denoted on the viewfinder screen. The center cross sensor is the most sensitive because it reads both vertical and horizontal shapes.

The AF system functions in light that is the ISO 100 equivalent of –1 EV to 18 EV (from low light to very bright conditions). There is also an AF illuminator on the built-in flash and accessory flash units, which helps the camera to focus in low light when using flash. However, the α100 provides reliable autofocus in surprisingly dark conditions even without that focus-assist feature.

Three options define how the AF areas (or focus frames) are used by the system: Wide AF area, Spot AF area, or Focus area selection. The camera also offers four AF modes: Single-shot AF (AF-S), Automatic AF (AF-A), Continuous AF (AF-C), and Direct Manual Focus (DMF). The latter simply allows you to fine-tune focus manually after focus is acquired by the autofocus system. You can also operate the α100 using full manual focus.

AF Modes

Use the AF/MF switch (located on left side of camera, below lens release button) to select autofocus. Then rotate the Function dial to the FOCUS position, press the Fn button, and use the Controller's down key to scroll to AF mode. Use the left/right Controller keys to select the mode you wish to use, then press the Center (Spot-AF) button in the center of the Controller to confirm your selection.

Single-Shot (AF-S): This option is intended for static subjects. Activate AF-S by holding the shutter button partway down. When focus is acquired, the AF area point in use lights red in the viewfinder and the focus confirmation signal lights steadily in the data panel at the bottom of the viewfinder screen. As long as slight pressure is maintained on the shutter button, focus remains locked—useful for recomposing without changing focus.

If the camera cannot find focus, the focus signal will blink in the viewfinder data panel; you cannot take a picture until focus is confirmed unless you have selected *Release priority* in Custom Menu 1 (see page 90). It may help to use the center cross sensor (called the Spot Focus frame) by placing it over the subject, locking focus by pressing the shutter button halfway, and recomposing. Should the subject move (toward or away from your position) before you take a shot, start the process over to set focus for the new camera-to-subject distance.

Automatic AF (AF-A): In this mode, the AF system switches automatically from Single-shot AF to Continuous AF mode if motion is detected in the subject. This default mode is recommended for multi-purpose use. If focus acquisition is not possible, the focus signal will blink in the viewfinder data panel; you cannot take a picture until focus is confirmed (indicated by the focus confirmation indicator in the viewfinder data panel) unless you have selected *Release priority* in Custom Menu 1.

AF-A mode is useful for subjects that might begin to move soon. Response to motion may take a second or two as the AF system adjusts for the changing camera-to-subject dis-

Continuous autofocus (AF-C) is made for action photography. AF-C constantly tracks a moving subject, greatly increasing the odds of making sharp images at sporting or other events where motion is a key factor.

tance. Hence, the first shot or two in a series may not be perfectly focused.

Continuous AF (AF-C): This mode tracks a moving subject. Focus is never locked automatically, but shifts continuously as the camera-to-subject distance changes. Focus lock is not available, and if you recompose, focus will change. (Some Maxxum/Dynax and Sony telephoto lenses incorporate a focus hold button that allows you to lock focus in AF-C mode.) The active AF area that finds focus will be illuminated in the viewfinder. If focus cannot be acquired, the camera will not allow you to take a photo; the focus indicator will blink in the viewfinder data panel.

Note: When AF-C is selected, the flash unit's focus-assist feature will not operate.

AF-C is ideal for action photography because tracking focus starts instantly without the delay that occurs in AF-A mode when the camera must switch between AF-S and AF-C. The system is most reliable (virtually foolproof) in brightly lit outdoor photography. It's not as reliable in very low light.

Direct Manual Focus (DMF): Select this option in order to fine-tune focus in AF-S mode without switching to manual focus. To use it, let the camera autofocus on a stationary subject. After focus has been confirmed, use the manual focus ring on the lens to make slight focus adjustments—for a person's eyes instead of the nose, for example.

Note: Do not attempt to adjust focus before you receive the camera's focus confirmation signal.

AF Area
Setting the AF area determines which focus detection points (called focus frames by Sony) will be used in finding and maintaining focus. Rotate the Function dial to the FOCUS position, press the Fn button and scroll through the three AF area options to select one of the following:

[] **Wide AF area:** This is the α100's default mode. All of the system's focus frames are active and the camera uses automated focus point selection. Focusing is completed when one or more of the nine focus detection points finds focus. The active focus point (or points, when the scene includes several objects at the same distance from the camera) are then illuminated in red on the viewing screen.

The automated system cannot read your mind, so it will not always use the focus detection point that covers your primary subject. In a scene with several objects, the system will select the closest subject or the object with the greatest contrast or most distinct texture. With "difficult" subjects (those with unusual patterns, for example), the central focus area will often set focus so that the object in the center of the frame will be sharpest. This is because the central focus area is cross-hatched—it includes both horizontal and verti-

cal sensors and is capable of acquiring focus even with sub-
jects that may frustrate the other focus detection points.

Note: While using the Wide AF area, you can switch at any
time to using only the central focus detection point — called
"Spot Focus." Simply press the Spot-AF button in the center
of the Controller and the camera will instantly focus using
only the central point. This feature is useful in a situation
described above, where the AF system is having trouble
focusing on the intended subject.

The Wide AF area option, with its automated focus point
selection, is often used for action photography because it
can focus on off-center subjects. It also works well for snap-
shots or point-and-shoot photography. Naturally, the system
will not always produce the intended effect, possibly focus-
ing on a secondary element that's closer to the camera or is
a more reliable target than your preferred subject.

⌐⌐ **Spot AF area:** The camera uses only the central focus
detection point (Spot Focus frame) when this is selected. Tar-
get your subject and lock focus by keeping the shutter but-
ton pressed halfway while recomposing. It is also a useful
focusing selection when subjects are approaching the cam-
era at high speed, such as an animal or a racecar. Spot-AF is
more reliable in low-light photography.

▓▓▓ **Focus Area Selection:** In this mode, you can select any
of the nine focus detection points (local focus frames) and you
can change the active frame at any time. Use the Controller
keys to select one of the outside focus areas while looking at
the subject through the viewfinder. Once a focus area is
selected, it will be briefly illuminated in red on the viewing
screen when it finds focus. To quickly select the central Spot
Focus frame, press the Spot-AF button.

After focus is acquired, it is locked by depressing a Con-
troller key or the Spot-AF button. You can then re-compose,
if desired, and focus will not change.

When you want to focus on an exact spot within a scene, such as the top of the stamen in the flower to the lower right, use only a single focus frame. You can also switch to manual focus for even greater control over the precise point of focus.

When you use this technique with the camera set to MultiSegment metering, exposure is also locked. Unless you switch to one of the other metering patterns, you cannot use this feature to set focus for one part of a scene while optimizing exposure for an entirely different area. When you're ready to switch to a different focus area point, use the Controller arrows to make your selection.

The ability to manually select any of the several focus area points is common to many brands of D-SLRs. This feature certainly sounds useful and logical. However, unless I'm shooting an action subject that may drift off-center, I generally use only the central focus area, often with focus lock (light pressure on the Center (Spot-AF) button or the camera's shutter button). Nevertheless, you may find circumstances where you'll want to select one of the other eight "local" focus area points, and that option is certainly available to you.

Manual Focus

To use full Manual Focus, set the AF/MF switch (on left front of camera, below lens release button) to the MF position. This disengages the autofocus system so you can focus manually at any time using the focus ring on your lens. If you are having trouble focusing, or you want to set focus in anticipation of an event, you can estimate the subject distance and set the focus accordingly. (Of course, this works only with lenses that include a focus distance scale.)

The focus signal in the data panel confirms focus by lighting steadily, and the active focus area lights up on the viewfinder screen. However, in this focus mode, you can take a picture anytime, even if focus is not confirmed.

I recommend switching to MF occasionally, especially in macro, landscape, and architectural photography when you may want to set the point of focus in the scene to control depth of field. The Manual Focus mode is also ideal for critical focus on a small, specific subject element: the eyes in a portrait or the stamen in the heart of a blossom, for example. Finally, it's a convenient method for focusing on one segment of a scene while setting exposure for an entirely different area.

☉/⏍ Drive Modes

The function of the drive modes is similar to that performed by the motor drive in a film camera. While no film has to be transported, these modes control the firing and recocking of the camera's shutter mechanism.

Set the drive mode by pressing the Drive mode button ☉/⏍ (on top of camera to right of Mode dial). Then use the Controller keys to highlight your selection on the LCD screen.

☐ Single-frame adv.

The α100's default drive, this selection will shoot one frame each time you press the shutter button until the cam-

era's memory buffer or memory card is full. Select this any time you simply want to shoot one image at a time rather than in a bracket or a burst.

⏏ **Continuous adv.**

In Continuous Advance the camera will keep recording images as long as the shutter button is held down. If you are using a high-speed memory card and shooting JPEGs, the camera will fire until the card is full. (With slower cards, the number of frames per burst may be limited.) This is useful when you want to shoot a series of images, whether friends being silly or action at a sports event. It will shoot up to 3 frames per second (fps) as long as the shutter speed is 1/250 second or faster. If longer shutter speeds are used, the framing rate will be slower.

Note: The framing rate can be quite slow when flash is used because the flash must recycle after each image in order to fire again. The recycle time depends on the amount of flash output used when making an image. There's a long recycle time when high output is required (great flash-to-subject distances), and a quick recycle time when lower output is required (with close subjects or in bright light).

⏲₁₀ **10s self-timer**

When the 10-second option is selected, the camera waits 10 seconds after the shutter button is pressed before it fires. This can be useful when the photographer wants to get into the picture and when the camera is mounted on a tripod. Focus and exposure are set when you first press the shutter button. If the lighting changes during the 10-second delay, the exposure may not be correct.

⏲₂ **2s self-timer**

Selected by scrolling down from the *10s* item, this option provides only a two-second delay between pressing the shutter and when the shutter actually fires. Because it raises the reflex mirror at the beginning of the countdown, this feature is useful for triggering the camera without creating movement or internal vibrations—serving a function similar to a

114

true mirror lock-up. It is often used for long exposures or when telephoto or macro lenses are utilized and the camera is on a tripod or other support. Focus and exposure are set when you first press the shutter button, so it is best used with fairly static subjects.

Hint: If you photograph birds or animals, it's best to use one of the optional remote control releases, RM-S1AM (short) or RM-L1AM (long), instead of using the self-timer. This will allow you to trip the shutter at exactly the right instant without jarring the camera. (The 2-second self timer/mirror lock-up feature is not often practical with moving subjects.)

Note: In addition to the familiar drive modes above, the Drive mode button also provides Exposure Bracketing options (see page 136) as well as White Balance Bracketing (see page 68).

Exposure

The term exposure in digital photography is defined as the amount of light that is required to create a likeness on the camera's image sensor. Ideally, the exposure should be "correct;" the image should depict the scene with clean whites, rich, dark blacks, and mid-tones that are not excessively light or dark. Important detail should be visible in both high-light and shadow areas.

Every camera's light metering (measuring) system is calibrated to provide ideal exposure with average or mid-tone subjects such as grass, rocks, trees, or a gray card. Using such mid-tone based metering, if the subject is very light, or if the scene includes a vast expanse of bright snow, sand, sky, or water, the image may be too dark or underexposed. Conversely, a black lava field or other very dark subject may be overexposed: too bright, or overexposed.

While the exposure was perfect, my first photo of the cars didn't quite have enough depth of field. I needed to use a smaller aperture. Using the principle of equivalent exposure, I decreased the size of the aperture one stop and increased the length of the shutter speed one stop to maintain the correct exposure.

At a given ISO setting, two factors control the amount of light that produces the image: the length of time that the camera's shutter is open and the size of the aperture (opening) in the lens. The selection of shutter speed and aperture can be left entirely to the camera or can be managed by the photographer using the camera's various exposure modes.

The Role of Shutter Speed and Aperture

In order to create an image with the desired amount of light, the correct combination of shutter speed and aperture must be selected. This ensures that the image is not excessively bright or excessively dark. The longer the shutter speed, the greater the amount of light that will strike the image sensor. The larger the aperture selected, the more light that will enter during any given exposure time.

Shutter speeds are denoted in seconds, or fractions of a second. Aperture size is denoted with f/numbers, also called f/stops. The smaller the f/number, the larger the aperture size. A wide aperture such as f/4 will allow far more light to enter the camera than a small aperture such as f/16 during any given time period. The camera's autoexposure system considers scene brightness and sets an f/stop and shutter speed that should produce a well-exposed image.

Note: Even the most sophisticated light meter—such as the segmented honeycomb pattern system—will not always produce a perfect exposure. Extremely light or dark-toned subjects may cause exposure errors. Also, an accurate exposure may not be the most pleasing or most appropriate for creative expression. That's why the α100 includes options for adjusting the exposure.

Equivalent Exposure

The camera's shutter speed and aperture steps (or stops) both increase and decrease exposure in equal amounts. Each full step increment doubles or halves the amount of light reaching the sensor. Thus, if you decrease the length of the shutter speed by one full stop and increase the size of the aperture by one full stop, the exposure will remain the same. Once the meter has determined the exposure for a scene, you can change the aperture or shutter speed in use, as long as you make a corresponding change in the other. Practically, this allows you to fine tune the appearance of the image without changing exposure—changing the aperture will influence depth of field in the photo and changing the shutter speed will control the rendering of motion.

Measuring Brightness

There once was a time when cameras did not contain any built-in system for measuring subject brightness. In those days you needed to use an accessory light meter or rely on estimates, experience, or expertise to make appropriate settings.

The α100, like many of today's D-SLRs, includes three light metering options. These are the 40-segment honeycomb

pattern (also called MultiSegment or evaluative, using artifi-
cial intelligence), the old-style center weighted averaging
system, and spot metering. You'll find specifics about each
later in this chapter.

ISO

The amount of light required for an accurate exposure
depends on the ISO setting you have selected on the cam-
era. ISO is an international standard for quantifying a film's
sensitivity to light. While digital cameras don't use film, ISO
numbers are still used to set the camera's sensitivity, or gain
(amplification). A low ISO number such as 100 denotes low
sensitivity to light. A high ISO number such as 800 or 1600
denotes high sensitivity to light. This factor is automatically
taken into account by the camera's light meter when making
calculations about the aperture and shutter speed combina-
tion that should produce a good exposure.

Note: ISO numbers are mathematically proportional, as are
shutter speeds and f/stops. As you double or halve the ISO
number, you double or halve the sensitivity (i.e., at ISO 800,
half as much light is required than at ISO 400; and at ISO
800, twice as much light is required than at ISO 1600.

The α100 allows you to choose an ISO from 100 to 3200,
although you'll rarely need to use the highest option. Since
noise increases with ISO, select ISO 100 for the best image
quality, and higher ISO levels as needed.

Rotate the Function dial to the ISO option and press the
Fn button to activate an item on the LCD monitor called
ISO/Zone Matching. Use the camera's Control dial or Con-
troller's keys to select a desired ISO level. Press the Center
button to confirm your selection.

One of the ISO choices is AUTO (not to be confused with
AUTO exposure mode). When it is selected, the camera will
set a low ISO in bright light and a higher ISO in darker con-
ditions to minimize the risk of blur from camera shake. (The
Super SteadyShot function is useful for this purpose too, but

For sunny scenes like this use a low ISO setting. In very bright situations, you may even want to try a neutral density filter to keep lighter areas from washing out.

it cannot compensate for subject movement or for camera shake at extremely long shutter speeds.)

When scrolling through the ISO options, you'll note two additional Zone Matching options: Lo 80 (for low key) and Hi 200 (for high key). Select Lo 80 for a scene primarily composed of dark toned and dark colored subjects, such as a man in a dark tuxedo against a black limousine. Select Hi 200 for scenes made of predominantly light tones, such as blonde ladies in white swimsuits on a white-sand beach. In either case, the camera adjusts exposure and contrast for a technically optimal rendition of a low or high key scene.

Exposure Modes

The α100 provides a wide range of exposure modes to suit many subjects or shooting situations. These are selected by rotating the Mode dial (on the right top of camera) to the appropriate icon or abbreviation.

Auto Mode (AUTO)

This was designed for maximum operating simplicity with the camera in total control of the aperture/shutter speed combination. In AUTO exposure, the camera uses its default settings, although you can set some overrides. Frankly, for anyone who wants to use a point-and-shoot approach, I suggest leaving all features at their factory-set default levels.

Scene Selection Modes

The α100 provides six different automatic modes, or programs, that use "intelligent" automation to make suitable exposure settings for common situations and subjects. After selecting one of these scene-specific modes by choosing its icon on the Mode dial, you can set certain camera functions and overrides, such as ISO, drive mode, etc. Again, because these scene selections are intended for point-and-shoot picture taking, we recommend using the camera's default settings.

Note: When any of the following programs is selected, the camera automatically activates the appropriate Color/DEC mode (see pages 72-74) to adjust color saturation, contrast and sharpening to a level considered most suitable for a specific type of subject. Also, the D-Range Optimizer's Standard mode is automatically activated (see pages 74-75).

Portrait: Selects a moderately wide aperture to blur the background; a telephoto lens is recommended for an even more blurred or less distinct background. Single-shot AF, AF-A autofocus, Spot AF, and Single-frame drive mode are automatically activated. Activate flash and it will fire in situations where it's needed.

[A] **Landscape:** Sets a moderately small aperture to opti-
mize depth of field (zone of acceptably sharp focus) and uses
the same AF and drive modes as Portrait program. A land-
scape is usually too far from the camera for flash to be useful.

[M] **Macro:** For extremely close focusing to fill the frame
with a small subject, this program sets moderate apertures
(such as f/5.6 or f/6.3) for moderate depth of field. That
should render the subject sharply while blurring the back-
ground. The same AF and drive modes are used as in Portrait
program. Do not use the built-in flash unless the subject is at
least a meter (40 inches) from the camera because the lens
may block some of the light. You can use accessory on-cam-
era flash but wireless off camera flash is preferable for rea-
sons discussed in the Flash chapter.

[S] **Sports action:** Favors fast shutter speeds to "freeze" a
moving subject. Continuous AF and Continuous Advance
drive mode are activated automatically. Flash can be used if
desired in low light, but in most action photography the sub-
ject might be far beyond the range of even a large accessory
flash unit.

[Sunset] **Sunset:** Very similar to Landscape program, but color
rendition is optimized for a rich, warm effect.

*Caution: Avoid viewing the sun directly or through the lens
because doing so can hurt your eyes.*

[Night] **Night View/Portrait:** Intended for taking photos of a
nearby subject against a moderately dark background, such
as a person posing in front of a city scene at night, with
flash (Night Portrait) or without flash (Night View). The
camera sets a long shutter speed, as long as two seconds in
dark locations.

In Night Portrait, the dark background has time to register
on the camera's sensor, while the nearby subject is lit by the
flash. Use a tripod to prevent blur from camera shake and
ask your subject to stay perfectly still to prevent motion blur.

121

Night View program (without flash) is intended for photos of a night scene at a distance, such as a city street with neon lights. Your picture will maintain the darkness of the night in the scene that surrounds your lit subject.

The camera sets a very long shutter speed, as long as 8 seconds in very dark locations, making a tripod necessary for sharp photos without blur from camera shake. Moving subjects, such as vehicles, will be blurred due to the long exposure time.

Program (P)
In this fully automatic mode the camera sets the shutter speed and aperture, but unlike AUTO, P mode allows you to change the aperture/shutter speed combination. Initially, the camera sets an aperture (f/stop) and shutter speed to provide a correct exposure. You can temporarily change the combination of settings—called Program Shift—by rotating the camera's Control dial (in front of the shutter button).

The Program shift feature does not change the exposure (image brightness). It allows you to select from its various shutter speed/aperture combinations that maintain an equivalent exposure. When using flash in P mode, the Program shift feature is disengaged. However, you can force the camera to select Slow Sync mode (flash with long shutter speeds) by pressing the AEL button.

Although P mode allows you to shift the aperture/shutter speed combination, I recommend using Aperture Priority (A) or Shutter Priority (S), discussed in the next sections. When you select an aperture (f/stop) in A mode or a shutter speed in S mode, the camera retains that setting and will not discard it when it switches to "sleep" mode as it does in Program mode. So if you have set f/22 or 1/15 second, the camera will maintain either of those settings until you intentionally make a change.

Aperture Priority (A)

Selected by choosing the A on the Mode dial, this semi-auto-matic exposure mode allows you to set any aperture available on the lens using the Control dial. The camera automatically sets a shutter speed that should yield a good exposure, according to its light meter's calculations. (In some cases, exposure compensation will be required for a perfect expo-sure.) All of the α100's functions and overrides are available.

When using flash with the α100 set to A mode, the cam-era will set a shutter that is no faster than the highest possi-ble flash synchronization speed: 1/160 second, or 1/125 sec-ond when Super SteadyShot is on. It will also not use a shut-ter speed slower than 1/60 second unless you press the AEL button to enter Slow Sync mode, a feature discussed on page 163. As all in modes, the shutter speed will be no faster than the highest possible flash synchronization speed: 1/160 sec-ond, or 1/125 second when the Anti-Shake function is on.

Aperture Priority mode is the best choice when you want to control depth of field, which is the range of apparent sharpness in front of the focused subject, and behind it.

Depth of Field—A Short Course

While the elements in your photos are usually three-dimen-sional, they are recorded on the sensor in two dimensions with a single plane of sharp focus. In other words, if you focus on a subject that is 3 meters from the camera, every-thing at the same distance will be sharply focused. Every-thing at different distances will appear less sharp.

However, when an image is viewed, there is an area in front of and behind the plane of sharp focus that is per-ceived to be in focus. This range of apparent sharpness is referred to as the depth of field. The factors that influence the amount of depth of field are:

- *The focused distance*
- *The focal length in use*
- *The shooting aperture*

By using a wide-angle lens and a small aperture (f/16), I was able to make an image with acceptable sharpness from the nearest element to the background.

If the focal length and subject distance are constant, depth of field will be shallower with large apertures (lower f/numbers) and deeper with small apertures (higher f/numbers). If the aperture and focused distance are constant, depth of field will be shallower with longer lenses (telephoto range) and deeper with shorter lenses (wide-angle range). If the focal length and aperture are constant, depth of field will be greater at longer focused distances and shallower with closer focused distances.

These things should be considered when planning your composition and the look of the finished photograph. Aperture Priority (A) mode is particularly useful because it allows you to select a desired aperture that will be maintained until you change it. The camera sets an appropriate shutter speed for a "good" exposure, although you can use overrides for a brighter or darker effect.

Depth-of-Field Preview: Today's lenses, including those compatible with the α100, use open-aperture metering. This means that they don't close down to the shooting aperture until a split second before the shutter opens to record an image. Until then, the aperture stays wide open, allowing the viewfinder to be as bright as possible for composing and focusing. However, having the lens at its maximum aperture doesn't allow you to judge depth of field at the shooting aperture. (Remember, as a lens closes down, depth of field increases.)

The α100 has a feature that closes the lens to the selected aperture so you can preview the depth of field as it will appear in the finished photograph. By pressing the depth-of-field preview button (located on front of camera to right of lens mount platform), you will see the effect of the lens aperture that will be used to create the image. The viewfinder will become darker and, depending on the lighting conditions and the selected shooting aperture, you should be able to see the elements in the scene well enough to judge sharpness. While this button is pressed, you can also change the aperture to experiment with how depth of field changes with various f/stop settings.

This invaluable feature allows you to fine-tune image sharpness. Sometimes you will want to assure that all elements of a composition—from foreground to background—will be rendered sharply in focus. Other times you will want some elements—usually a cluttered background—to be soft so they don't compete with the subject. Either way, the depth-of-field preview is the easiest and most precise method of judging the degree of sharpness of various parts of a composition.

Depth of Field Shooting Tips: In close-up photography, depth of field is limited. So to maximize it, choose a small aperture. You may also wish to control the point of focus to further maximize depth of field. (Remember that focused distance is part of the formula that is especially important at close ranges.) Take advantage of the camera's depth-of-field preview button. If depth of field is not adequate, you can use a smaller

125

aperture, or readjust the point of focus. For example, when photographing a flower, you may find that overall sharpness will be improved by focusing on a different part of the flower. Also, for best results in close-up photography, use of a tripod or other camera support is necessary.

A soft, out-of-focus background is preferred for portrait photography because it will not draw the viewer's eye away from the subject. To accomplish this, choose a large aperture (small f/number.) Because telephoto lenses have less inherent depth of field than shorter focal lengths, they are ideal for isolating the subject against a softly blurred background. You can always check the effect using the camera's depth-of-field preview.

For landscape photography, maximizing depth of field will render more of the scene in focus. Besides using a small aperture (higher f/number), controlling the point of focus will make the most of the depth of field. As a rule of thumb, depth of field will extend about 1/3 in front of the point of focus and 2/3 behind it. Thus, focusing somewhere in the front-to-middle portion of the scene will yield the greatest amount of sharpness. You can check the depth-of-field information provided with your lens, or use the camera's depth-of-field preview button to make sure that elements of the scene are as sharp as possible. Take advantage of the lens or focal length to create a pleasing scenic view. Not only does a wide-angle lens allow you to capture sweeping vistas, but it also maximizes the depth of field in the photograph.

Hint: If you want to achieve critical control of depth of field, take the same shot at several apertures: f/11, f/16 and f/22, perhaps.

Shutter Priority (S)
When you want to control how motion is rendered in the photo, switch to the camera's S mode. This semi-automatic mode allows you to select a shutter speed, and the camera will set the appropriate f/stop for a suitable exposure. (In some cases, exposure compensation will be required for a perfect exposure.)

When using flash in S mode, the camera will allow you to select a shutter speed as long as 30 seconds. However, when using flash, if you set a shutter speed faster than the flash sync speed of 1/160 second (or 1/125 second when the Super SteadyShot function is on), the camera will override and revert to the flash sync speed. (Flash will always fire in Fill-flash mode, even in bright scenes, when the build-in unit is up or when an accessory flash unit is on.)

The following chart may be useful as a tool for learning the meaning of many common shutter speed abbreviations that you are likely to encounter in any camera exposure mode. It does not include every available option, but once you understand the concept, you'll have no difficulty in determining the exact shutter speed.

1000:	1/1000 second
60:	1/60 second
15:	1/15 second
1":	one second
1"5:	one and a half seconds
15":	fifteen seconds

Shutter Speed Considerations: Aside from using a shutter speed that will produce a sharp photo—without blur from camera shake—there's another important reason for selecting a slow or fast shutter speed: the ability to control how motion is portrayed in the photo. To appreciate the concept, take several shots of moving cars at a fast shutter speed such as 1/500 second. Do the same at a slow shutter speed such as 1/15 second. Analyze the resulting images and you should find that the first set is quite sharp while the second depicts the subject with motion blur.

This is useful for creative purposes, allowing you to control the way that a moving subject will appear in your images. Think of a waterfall for example. If you shoot at 1/500 second, the droplets of water will appear to be frozen in mid-air; that may not provide the flowing effect

that you want. Put the camera on a tripod and switch to a shutter speed of 1/4 of a second and the water will be blurred, producing a convincing portrayal of the motion of flowing water.

Note: When you select a faster shutter speed in S mode, such as 1/500 second, the camera will set a wider aperture to assure correct exposure, so depth of field will therefore be reduced. When you select long shutter speeds, the camera will set a small aperture, so the image will then exhibit greater depth of field. This is more noticeable when you shoot at a low ISO setting, such as ISO 100. If you want to use fast shutter speeds, plus smaller apertures for more depth of field, switch to ISO 400 in bright light and ISO 800 on overcast days.

In action photography, we often use fast shutter speeds to render the subject without motion blur. But sometimes it may be preferable to convey the feeling of motion by using a relatively slow shutter speed, such as 1/30 second. In this case the subject will be blurred instead of "frozen" or static. This option works best with subjects moving across the frame from the left or right, thus traveling across your line of vision. Pan (move the camera) at the same speed as your subject is moving. It helps to use a tripod with a pan head and to begin a little before tripping the shutter release. In the resulting image, the subject should be quite sharp, though with some motion blur, while the background will exhibit obvious blur. If the action is occurring close to the camera, try also using flash in Rear curtain sync mode during a long exposure for some of your shots, as discussed in the chapter on flash photography.

The pan/blur technique takes practice because it requires you to move the camera at exactly the right speed. You may need to shoot quite a few frames to get one that's nearly perfect, technically and aesthetically. Through persistent trial and error, you'll become more skilful with effective panning.

To freeze the action, use a fast shutter speed, probably 1/250 second or shorter.

Exposure Control Range Warnings

Despite the best efforts of the autoexposure system to produce correct exposure, there are times when subject conditions are beyond the system's range. In such cases the camera provides various warnings so you can take corrective action.

When using the AUTO, P, or one of the scene modes, both the aperture and the shutter speed displays in the viewfinder will blink if the exposure is beyond the limits of the camera's autoexposure system. If the scene is too bright, the fastest shutter speed and the smallest aperture will blink. You can address the warning by setting a lower ISO level or by placing a neutral density filter on your lens.

If on the other hand the scene is too dark, the camera's slowest shutter speed (30 seconds) and the largest possible aperture for the lens will blink. In this case, try increasing the ISO and use flash.

In A mode, the display for shutter speed will flash to indicate exposure outside its range. For example, if you select a large aperture (low f/number) in bright light when using a high ISO setting, the camera's highest shutter speed (1/4000 second) may not be fast enough to provide a correct exposure. When this happens, lower the ISO, add a neutral density filter, or adjust the f/stop until the shutter speed stops flashing. In dark conditions, the camera's longest shutter speed will blink. If so, change the f/stop until the blinking stops, set a higher ISO, or use flash.

If you are shooting in S mode, depending on the shutter speed, ISO setting, and brightness of the scene, the camera may not be able to set an aperture that produces a correct exposure. In that case, the largest or smallest aperture will blink. With a bright scene, lower the ISO or increase the shutter speed until the aperture display stops blinking. In dark conditions, raise the ISO, decrease the shutter speed, and/or use flash.

Manual (M)
Manual mode allows you to select any aperture/shutter speed combination even if that will produce exposures that are different from the camera's recommendation. That's because Manual mode was intended to provide the ability to intentionally overexpose or underexpose an image for creative purposes. A scale in the viewfinder data panel, and in the LCD monitor, shows the amount of deviation from the meter-recommended exposure at the aperture and shutter speed you have set.

Experiment with M mode by selecting a shutter speed with the Control dial. In order to change the aperture, press and hold the exposure compensation button (+/-) on the back of the camera while rotating the Control dial. (This selection process can be reversed, using a function available in Custom Menu 1, see page 92.)

Depending on your aperture/shutter speed selections, an image may be correctly exposed, according to the light meter (0 on the scale), or overexposed (+) or underexposed (-). The scale also shows the extent that your exposure will vary from the recommended "correct" exposure. A reading of +1 for example, indicates that the image will be overexposed by one Exposure Value (EV), while -1 indicates underexposure by one EV. The scale is marked in increments of one-third (0.33) EV.

One EV is equivalent to one aperture stop or one shutter-speed step. It's quite a large increment in digital photography; over or underexposure by one EV is generally obvious in an image. An EV factor of 0.33 is less noticeable in an image.

Manual exposure technique is somewhat complex. Unless you are already proficient in Manual exposure control, you may want to experiment before relying on M mode.

Note: The α100 includes a feature called Manual Shift that allows you to change the f/stop / shutter speed combination without affecting the exposure. To use this, set the aperture and shutter speed. Next, lock in that exposure level by pressing and holding the AEL button. Any subsequent changes—to f/stop for depth of field control, or shutter speed for control of the rendition of motion—will not change the image brightness. If you do enjoy shooting in fully manual mode, this feature may be helpful to you.

Bulb Exposure
The longest shutter speed that you can select is 30 seconds, but there is another option for making even longer exposures: BULB. The term relates to an historically early photo accessory that used a blower bulb attached to a hose to trip the camera's shutter.

Set the Mode dial to M, and then decrease the shutter speed until the LCD display says BULB. The camera's shutter will remain open as long as the shutter button is held all the way down. (An optional remote-control cable accessory

should be used to trip and lock the shutter to eliminate camera shake.) A tripod must be used for sharp images during long exposures, and it is best to put the eyepiece cap in place to prevent light from entering through the viewfinder and affecting the exposure.

The camera's light meter is disengaged, so you will need to use a handheld meter to calculate exposure. The Super SteadyShot system is also disabled. This option is most useful for night photography to record the moon and stars, a dark cityscape, or fireworks, for example.

Metering Method

It's important to understand the camera's light metering strategies in each of the three options available. These are set by rotating the Function dial to the metering icon ▣ , pressing the Fn button, and scrolling to the desired mode with the Controller's keys. The following options are available:

▣ MultiSegment Metering
This is an evaluative system that employs a 40-segment honeycomb pattern and artificial intelligence to analyze brightness in all areas of a scene. The system also considers subject distance if you are using a Maxxum/Dynax D series lens (with distance data detector chip) or any Sony or Carl Zeiss Alpha lens. When the camera is set to autofocus, subject position data provided by the AF system is also considered in the metering computer's analysis.

Because the system compares exposure data with pre-programmed exposure models, it is quite successful at metering subjects with unusual reflectances. For example, in strong backlighting—a friend posing against a setting sun, for example—the system increases exposure automatically to reduce the risk of a dark image. It uses the same strategy for any scene possessing high reflectance, whether a sunny, snow-covered landscape or a close-up of a bride in white.

The metering system should also compensate for a dark-toned subject, such as a lava field, reducing exposure to render it as black, instead of gray.

While this is a sophisticated metering system that usually provides close to optimal exposures, its recommendations may not always be ideal. Scenes that are difficult to meter may sometimes require slight adjustments.

Slight exposure errors may or may not be a problem, depending on whether or not you can correct the errors with image processing software. But even when shooting with RAW, which offers more capacity than JPEG for post-shooting exposure correction without degrading image quality, it is worth taking the time to get a well-exposed image in-camera, using exposure compensation if necessary.

◉ Spot Metering

Spot metering measures only the portion of the scene within the small circular area in the center of the viewfinder. To use it, point the lens so that the central circle etched on the viewing screen covers the target you intend to meter.

One of the most valuable uses of spot metering is to measure light values in different parts of a scene for comparison or to determine the exposure gradient in the scene. Another common scenario is a spot lit performer (small in the frame) against a dark background. Or you might be shooting a small, mid-tone subject located in very bright surroundings, such as a cabin in the snow on a sunny day. These types of shots often produce exposure that is not optimal with other metering patterns.

In the above cases, meter your primary subject, then press and hold the AEL button to make sure that the locked-in exposure does not change while you recompose. When you take the shot, the exposure will be optimized for the primary subject.

In order to make an accurate exposure of this primarily light-toned scene, I took a spot meter reading from a midtone (the shrub in the foreground) and used AE Lock while recomposing in order to keep the correct exposure value locked in.

With experience, this is a useful type of metering. But it can also be tricky because the exposure is significantly affected by the brightness of the selected area. If the target is a mid-tone (a tanned face, for example), the exposure will be accurate. But if you take a spot meter reading of a light-toned area, underexposure will occur. And if you spot meter a dark area, the image may easily be overexposed. Consequently, spot metering can produce images that vary within a wide range of exposure. You might need to apply exposure compensation for a correct overall exposure.

⊙ Center Weighted Metering

Center weighted measures brightness over most of the scene and averages it, but it applies extra weight to a large central area. The system does not employ any "intelligent" evaluation.

Photographers who have shot with film SLRs that used this system may continue to use center weighted metering, selecting an appropriate amount of exposure compensation based on experience or rules of thumb. When applied with expertise, this technique can produce excellent exposures. However, in general you will get better results with the camera's MultiSegment metering system. You are also better off using spot rather than center weighted metering with difficult subjects or when it is advantageous to precisely meter a small area.

Exposure Compensation

After taking a shot, check it on the LCD monitor. If you think it's too bright or too dark, set some exposure compensation and re-shoot. (This can be used in any mode except M.) This feature is accessed with the +/- button (on back of camera to right of viewfinder). While pressing and holding that button, rotate the Control dial to select a + (plus) value for a brighter image or a – (minus) value for a darker image. Watch the scale in the LCD monitor change to reflect your settings and stop when you reach a desired level of compensation.

The camera can make changes toward the plus side or the minus side in 1/3 (0.33) EV increments. EV denotes exposure value, and one full EV change equals one full aperture stop or one full shutter speed step, either of which doubles or halves the light.

When shooting with MultiSegment metering, few scenes will require more than a + 0.7 or - 0.7 EV of exposure compensation. Take a shot without compensation and review it in the Playback mode—preferably using the histogram (discussed

on pages 142-147)—for an exposure analysis. If you're not satisfied, set a plus compensation factor for a brighter image or a minus factor for a darker image, and re-shoot.

D-Range Optimizer

Although technically not considered an exposure control, D-Range Optimizer does affect exposure. Different effects are provided by the Standard (D-R) mode and the Advanced (D-R+) mode. In a nutshell, Standard mode lightens shadow areas in underexposed images while Advanced mode, somewhat more sophisticated, lightens shadow areas and darkens highlight areas in scenes that you photograph under extremely harsh, contrasty light, attempting to retain detail in both dark areas and very bright areas. See pages 74-75 for further explanation.

Exposure Bracketing

This function allows you to shoot three successive frames while the camera automatically sets different exposure for each. This increases your chances of getting the optimal exposure with any given subject in any given lighting condition. Exposure bracketing is selected with the drive button ⟳/⬛ on top of the camera and scrolling with the Controller keys to the desired choice:

• ⬛⁰³c **Bracket 03C:** Pressing and holding the shutter button causes the camera to fire three frames in a continuous burst with a slight 0.3 EV difference in exposure.

• ⬛⁰⁷c **Bracket 07C:** This choice also fires three frames in a continuous burst but with a greater difference in each exposure: 0.7EV.

• ⬛⁰³s **Bracket 03S:** Uses Single frame advance (press the shutter button separately three consecutive times) to make three frames, each with a 0.3 EV difference in exposure.

136

• 📷 **Bracket 07S:** This also fires three frames using Single frame advance, but with a difference in exposure of 0.7EV.

In continuous bracketing, only the last image of the series will be displayed in the LCD monitor.

The sequence for bracketing is 0 for the first frame, minus (-) exposure compensation for the next frame, and plus (+) exposure compensation for the last frame of the series. This sequence can be changed in Recording Menu 2 as described on page 85.

Bracketing can be useful when you are not certain how much exposure compensation to set, or whether or not some plus or minus compensation would produce the most visually pleasing exposure. When using bracketing, you can also apply general exposure compensation to the whole set of frames. However, I don't recommend this except in extreme circumstances.

Note: When flash is active, the bracketing function varies the flash exposure only. Only Single frame bracketing is available, so you'll need to take three distinct shots each time the flash has recycled and is ready.

A scene that is backlit will usually have an underexposed subject. In this urban landscape, that was prevented by metering a building in the foreground and holding the AE Lock button while recomposing the scene.

Autoexposure Lock (AEL)

In any of the autoexposure modes, the AEL option lets you meter a portion of a scene and lock the exposure value so that you can recompose your shot. This is useful in spot metering with off-center subjects.

To activate this function, point the lens at the area you wish to meter and press the AEL button on the back of the camera in the upper right corner. Hold the button as you recompose and set autofocus with a light touch on the shutter button. When you're ready to take the shot, fully depress the shutter.

If you plan to use the AEL technique, set some exposure compensation if your target is light-toned or dark-toned. This should help to assure correct exposure. For example, set perhaps +1 if you plan to take the light meter reading (using MultiSegment metering) from a white egret. Or maybe set -2/3 if taking the meter reading from a black cat. Then activate the AEL, recompose for the desired framing, and take the shot.

Note: When flash is active, the AEL button cannot be used to lock exposure. In this case, depressing it will set a long shutter speed for Slow sync flash photography in all exposure modes except Shutter Priority and Manual (see page 163).

Exposure Evaluation

In addition to visual image review on the LCD monitor, there are two more accurate ways to evaluate exposure. These are the Luminance Limit Warning and the histogram, which are available in instant playback or in the camera's full Playback mode.

To activate these features, press the up key on the Controller while viewing an image in instant image review or in the camera's Playback mode. The image displayed will now be smaller in the LCD monitor. Excessively bright areas, as well as excessively dark areas, will blink within the displayed image, thanks to the Luminance Limit Warning.And a "hilly" type of graph—called a histogram—will appear below the image.

Luminance Limit Warning
This feature highlights areas of a photo that are excessively dark or excessively bright. When bright areas of the displayed image flash, highlights are "blown out," or too bright to hold detail. When shadow areas flash, they are "blocked up," or too dark to show detail.

Each type of warning (highlight or shadow) flashes alternately; the display uses a different type of pattern for each in order to avoid confusion. This Luminance Limit Warning is not as informative as the histogram display, but it's logical, intuitive, and easier to interpret. It can certainly help you avoid the most serious exposure problems.

Consider a situation where highlight detail or texture is important, as in a bride's dress or the texture of a flower petal. After taking a shot, check the image, looking closely for a highlight warning in the pertinent area. If it flashes, you'll probably want to re-shoot. Set a –0.3 exposure compensation; review the image in Playback mode and check for a warning again. If necessary, re-shoot again, using a –0.7 exposure compensation factor, and check the image again for a highlight warning. Keep an eye on shadow warnings at the same time, if there is also important detail in shadow areas.

When portions of your image are overexposed, the Luminance Limit *Warning will blink, indicating loss of highlight detail. For example, you can't see the folds or any designs in the fabric of this bride's gown. You can set a minus exposure compensation value and re-shoot for a better rendering of the dress.*

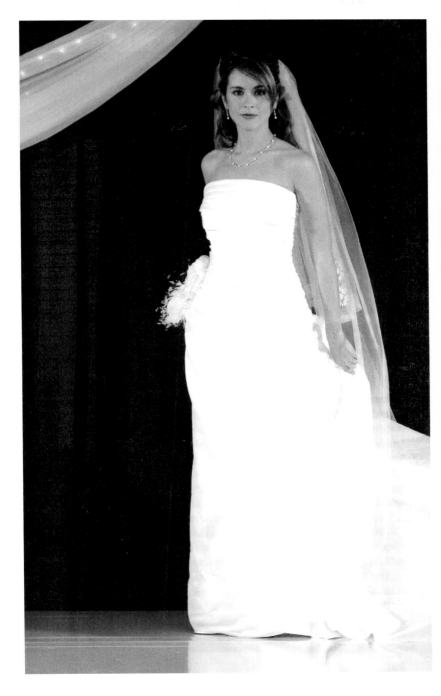

Hint: Although highlight detail is often the most important, be careful when shooting a dark-toned subject. Underexposure—particularly images made at ISO 400 or higher settings—will tend to overemphasize digital noise. When possible, re-shoot several times, increasing the amount of plus exposure compensation for each shot. You can always darken the image in the computer, which will not affect digital noise. However, lightening the shadow areas in post processing will usually cause any preexisting noise to be more noticeable.

Sometimes shadow detail or texture is important—as in the fur of your black cat. In that case, pay attention to the shadow warning. If an important shadow area blinks, you may well choose to re-shoot. Set a bit of plus compensation to increase the exposure, allowing the camera to record more detail. But beware of overexposing important highlights; setting too much plus exposure compensation can produce flashing in the highlight areas.

The Histogram
The histogram is of a graph that appears on the LCD monitor indicating brightness distribution from black (on the left side of the graph) to white (on the right side) along the horizontal axis. A dark image will be weighted to the left, a bright image will be weighted to the right. Mid-tone brightness distribution is represented in the central area of the graph. The vertical axis indicates the pixel quantity existing for the different levels of brightness.

If the graph rises as a typical bell-shaped curve, from the bottom left corner of the histogram to a peak in the middle, then descends to the bottom right corner, all the tones of the scene are captured. If the graph starts or ends too far up on either the left or right vertical axis of the histogram, so that the "slope" looks like it is cut off, then the camera is cutting off data from those areas. Some loss of detail is inevitable when the contrast range is beyond the capabilities of the camera—a dark-toned subject surrounded by extremely bright sky or water, for example.

When the histogram is heavily weighted towards either the dark or bright side of the graph, detail may also be lost in the sparser of the two areas. However, some scenes are naturally dark or light in tone. In these cases, most of the graph can be on one side of the scale.

To render detail in highlight areas, control exposure so the slope on the right reaches the bottom of the graph before it hits the right vertical axis and "drops off" that side. If a scene includes detail elements in shadow areas, manage exposure so that the left side of the slope reaches the bottom of the histogram before it hits the left vertical axis, realizing that the "real" world is not perfect and you can't always produce a perfect histogram.

Check the histogram after taking a shot and, if necessary, re-shoot using a plus or minus exposure compensation setting. Then check the histogram again for the new image. Also see whether the compensation has produced any undesired blown highlights or blocked shadows. Of course, when shadow detail is most important, you may need to tolerate some loss of detail in the brightest areas, and vice versa.

Both the Luminance Limit Warning and the histogram provide feedback on exposure and contrast. Once you review the information they provide, you can choose to re-shoot the image with a different exposure and/or contrast. Although some people count on "fixing" exposure problems with software after downloading image files into the computer, you can't add detail that was never captured in the first place. Whether shooting JPEGs or RAW files, always get the best image possible in camera.

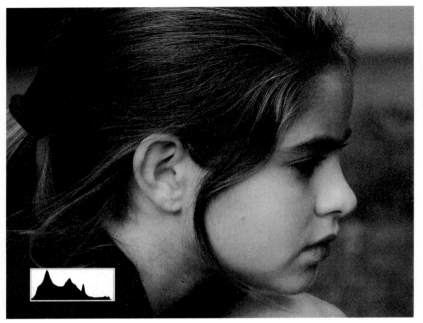

Image A © *Kevin Kopp*

Image A: If the graph rises from the bottom left corner of the histogram, then descends towards the bottom right corner, all the tones of the scene are captured. (There may be a few peaks and valleys involved, but the graph still rises from the left and ends very close to the right axis). The image will include pure black, pure white, and a good distribution of mid-tone, for an exposure that's correct overall.

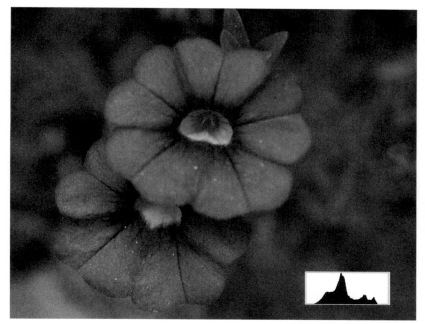

Image B © *Kevin Kopp*

Image B: With some images, the slope will drop before it reaches either the left or right side of the scale. In other words, the graph starts too far in from one or both edges. This indicates that the image does not contain rich dark blacks or bright pure white tones. (Remember, black is represented on the left of the graph and white on the right.)

The image consists primarily of mid-tones and grayish blacks and grayish whites. This does not necessarily mean poor exposure; in fact, it signifies low contrast. That's easy to correct in the computer, or by setting a slightly higher contrast level in-camera (see page 73). Of course, you may decide to set some plus or minus exposure compensation before taking the shot again. That will produce brighter whites or darker black tones.

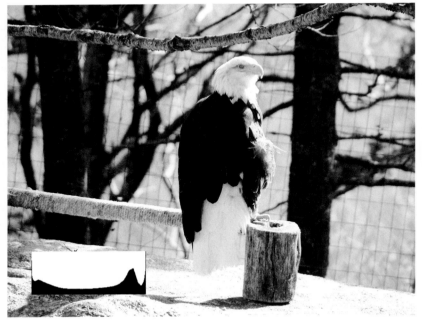

Image C © *Kevin Kopp*

Image C: With extremely high contrast subjects (including very dark shadow areas plus very bright highlights), the histogram may show a slope that is cut off at both ends. This indicates that detail will be lost in both highlight and shadow areas. Dark sections of your photo may fade to black, and brighter sections may appear completely washed out.

Try re-shooting an image of this type, using a low contrast setting in-camera. For nearby subjects, try using flash to even out the lighting for gentler overall contrast. If the light is changing, wait until a cloud covers the sun, moderating excessive contrast.

Image D © *Kevin Kopp*

Image D: In some images, a portrait of a bride in white or a sunlit flower for examples, highlight details are important. In those cases, be sure the slope on the right reaches the bottom of the graph before it hits the right side. Otherwise, the image will not hold detail in bright areas of the photo; these details will be blown out as demonstrated in the whites of this lunch-time vendor. Re-shoot, using a minus exposure compensation setting.

Flash Photography

Electronic flash is not just a supplement for insufficient lighting but can also be a great tool for creative photography. Flash is highly controllable, its color is precise, and the results are repeatable. However, many photographers shy away from using on-camera flash because it can be harsh and unflattering, and taking the flash off the camera used to be a complicated procedure with less than sure results. The sophisticated flash options available with the α100—especially with a compatible accessory flash unit—eliminate many of these concerns. Remember too, the LCD monitor provides instantaneous feedback showing whether the flash exposure was right or not. You can make adjustments if you are not satisfied with your flash exposure.

However, it is still helpful to understand the basics of how flash photography works. The following are some of the important standards.

The Inverse Square Law

It's not difficult to understand one of the essential concepts at work with flash photography. As light travels away from its source it also spreads outward, losing intensity. Consequently the Inverse Square Law, a fundamental principle of light, says that light intensity is reduced by a factor of four as the distance from a source—in this case your flash unit—doubles. Light level drops dramatically according to distance. In fact, if you are three feet from your subject, you need four times as much light to maintain the same level of exposure when you move six feet away from the subject.

✑ *Mastering flash photography can dramatically enhance the quality of your photographs. Sony's dedicated accessory flash units used with Sony lenses allow the α100 to control flash output using ADI flash metering.*

Guide Numbers

Guide numbers (GN) are a comparative reference used to quantify flash output. They are expressed in terms of ISO, in feet and/or meters. The formula to determine guide numbers is GN = distance x aperture. So (according to the Inverse Square Law), a flash unit with a GN of 100 in feet (30.5 meters) puts out four times the amount of light as one with a GN of 50 in feet (15.25 meters). If your accessory flash has a zoom head, the GN will vary according to the zoom setting.

Flash Synchronization

The α100 has a focal plane shutter that consists of two shutter curtains. When you press the shutter release button, the first curtain opens to uncover the camera's sensor and the second curtain covers it. The shutter speed determines the length of time between the first curtain opening and the second curtain closing. To take a photo with flash, the flash must fire when the camera's first shutter curtain is open across the entire frame and before the second curtain begins to close. The fastest speed at which the flash fires while the shutter is fully open is called the flash synchronization speed or sync speed. The α100 has a sync speed of 1/160 second or 1/125 second when Super SteadyShot is on. When using the built-in flash or a dedicated accessory flash, the camera will not let you set a shutter speed faster than the sync speed. (Some accessory flash units have High-speed sync to use flash with fast shutter speeds. See page 166.)

The Built-in Flash

In order to operate the built-in flash you must first manually raise it. You can then use the Function dial and Fn button to select either AUTO (*Autoflash*), ⚡ (*Fill-flash*), or REAR (*Rear syn.*) flash modes (see also pages 157-162). The built-in flash is also necessary to utilize the WL (*Wireless*) flash mode.

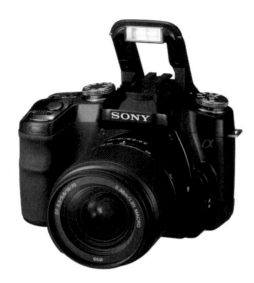

Not as powerful as an accessory flash, the built-in flash can be effective as long as you are aware of its limitations. Review you flash pictures immediately in the LCD and adjust as necessary, by increasing the ISO or moving closer to your subject, if you find the image is underexposed. Photo courtesy of Sony Corporation.

Good photos are definitely possible when using the built-in flash unit. Simply set the camera to the AUTO exposure mode. By the time you have composed and focused, the flash should be charged and ready to fire, confirmed by a lightning bolt symbol in the viewfinder data panel. The camera will set a suitable aperture and shutter speed. It will also set the right flash power output, or intensity. The image should be well exposed as long as your subject is within the flash range (see next page).

You cannot take additional shots while the lighting bolt is blinking, indicating the flash unit is recycling or charging. When the blinking stops, the flash is ready. Remember, however, that the built-in flash draws power from the camera's battery. Frequent flash use will reduce battery life. It's always a good idea to carry a charged spare camera battery.

Flash Range
The built-in unit is not particularly powerful, but it has adequate range for most snapshots and people pictures. The effective range varies with the aperture that's used: it's

greater at larger apertures (f/4 for example) than at smaller ones (f/11). Effective range also varies depending on the ISO selected: it's greater at higher ISO settings. The following chart provides effective flash range at f/4, a common maximum aperture at the short end of many variable aperture zoom lenses, and at f/5.6, a maximum aperture that's common with these lenses at the medium to longer focal lengths.

ISO Setting	f/4	f/5.6
Lo80	1 - 2.7m 3.3 - 8.8 ft.	1 - 1.9m 3.3 - 6.2 ft.
100	1 - 3m 3.3 - 9.8 ft.	1 - 2.1m 3.3 - 6.7 ft.
200 or Hi200	1 - 4.3m 3.3 - 14 ft.	1 - 3m 3.3 - 9.8 ft.
400	1- 6m 3.3 - 20 ft.	1 - 4.3m 3.3 - 14 ft.
800	1.4 - 8.6m 4.6 - 28 ft.	1 - 6m 3.3 - 20 ft.
1600	2 - 12m 6.6 - 39 ft.	1.4 - 8.6m 4.6 - 28 ft.

Hint: Photocopy this chart and carry it in your camera bag along with the wallet card found in the back of this book. And don't ignore the minimum range. Moving very close for a frame-filling close-up—especially when using a high ISO setting—can produce excessively bright flash photos.

Although the flash range is impressive at ISO 800 and particularly at ISO 1600, remember that image quality will be lower due to increased digital noise at such settings. Consequently, you might consider buying one of the powerful accessory Sony HVL-series flash units (with at least double the range). This will allow you to shoot at lower ISO settings for superior image quality.

Accessory Flash Units

The α100 supports full-featured flash photography with the compatible accessory flash units. These include the Sony HVL-F56AM and HVL-F36AM models, as well as (discontinued) Maxxum/Dynax D-series flash units. With these you can take advantage of wireless off-camera TTL flash, high-sync speed flash, rear-curtain flash synchronization, bounce flash, and advanced off-camera setups for sophisticated flash effects discussed in this chapter.

These dedicated flash units also allow you to utilize sophisticated ADI (Advanced Distance Integration) flash metering. However, that also requires the use of D-series Maxxum/Dynax lenses, Sony lenses, or the Carl Zeiss Alpha series designed for the α100. All of these lenses include the distance data detector chip. ADI flash uses distance information from the appropriate lenses to control the flash output and is less affected by very bright or very dark subjects than is Pre-flash TTL metering, which does not use distance information (see page 156). (Also, distance data is not employed by the flash metering system when non D-series lenses are used).

Flash Compatibility

Because the α100 employs the same flash metering system as the (now discontinued) Maxxum/Dynax 5D and 7D, there is extensive compatibility between the various cameras and flash accessories of both brands. In addition to the Sony HVL series flash units, the α100 is fully compatible with the (discontinued) Maxxum/Dynax HS-D, D and Macro series flash units. By the same token, the four Sony HVL-series flash units are fully compatible with the Maxxum 5D and 7D cameras. While some older Maxxum/Dynax flash units (not HS-D or D series) can also be used with the α100, they require optional Sony Flash Shoe Adapter FA-SA1AM and they must also be used in Manual flash mode.

Sony Flash Units

Sony Flash HVL-F56AM

This is a large model with high power output. Its Guide Number (GN) is 185/56 (feet/meters) at ISO 100 using the 85mm zoom head setting. This model features an illuminated LCD data panel, power zoom flash head to match focal lengths from 24mm to 85mm, wide-angle diffusion panel (for use with lenses as short as 17mm), focus-assist illuminator, plus several functions for additional creative options. In addition to conventional upward tilt capability, this unit allows for tilting the head 10° downward for close-up photography, and can be rotated to the side for bouncing flash from a wall.

Flash HVL-F36AM

This is a more compact unit with lower power output. The GN is 118/36 (feet/meters) at ISO 100 using the 85mm zoom head setting. It lacks an LCD data panel, but has a power zoom flash head to match focal lengths from 24mm to 85mm, a wide-angle diffusion panel (for use with lenses as short as 17mm), and a focus-assist illuminator. The head only tilts upward for bouncing flash off a ceiling.

Macro Flash Units

The Sony HVL Macro Flash units consist of two parts: the flash head(s) that attach to a Macro lens using a provided adapter ring, plus a controller that mounts in the camera's hot shoe. The two components are connected with a cable.

Macro Ring Light HVL-RLAM: This is a professional caliber unit designed for extreme close-up photography with a Macro lens. It's quite powerful with a GN of 79/24 (feet/meters) at ISO 100. Its circular head includes four flash tubes that can be individually illuminated. Use all four for even lighting, or select specific tubes for more directional lighting. The kit includes 49mm and 55mm adapter rings for attaching the ring light to the front of the lens. Note that this ring light comes with the required accessory flash shoe adapter (Sony FA-SA1M or Konica Minolta FS-1100) to mount the controller in the hot shoe of the α100 or

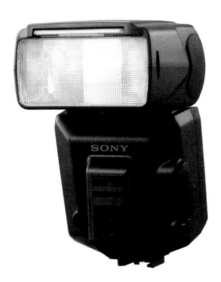

Sony's most powerful accessory flash is the HVL-56AM. Photo courtesy of Sony Corporation.

Maxxum/Dynax 5D and 7D cameras. The flash unit is also sold without the flash shoe adaptor as the Macro Ring Light HVL-RLA.

Macro Twin Flash Kit HVL-MT24AM: Like the Macro Ring Light, the Twin Flash Kit uses a controller that mounts in the camera's hot shoe and lighting that mounts on the front of the lens. Instead of a circular flash, the unit uses two separate small flash heads on adjustable arms. Either or both flash tubes can be used at any time. Each flash head has a GN of 40/12 (feet/meters). The Twin Flash Kit comes with 49mm and 55mm adaptor rings, wide-angle diffusion panels, and a storage pouch.

Flash Metering Options

The camera allows you to select from two options for flash metering control in Recording Menu 2. The following information clarifies some of the concepts relating to those options.

ADI Flash (Advanced Distance Integration)

This is the most sophisticated TTL (through the lens) metering option. It's available only when using Sony, Carl Zeiss Alpha, or Maxxum/Dynax D-series lenses and either the built-in flash or a fully compatible accessory flash unit. The camera's microcomputer uses focus distance data provided by the lens as well as aperture and ISO information to set the flash exposure. This increases the odds of a good exposure because it is less influenced by high or low subject reflectance, therefore more likely to produce a good exposure with white or black subjects that might otherwise lead to under- or over exposure, respectively. I recommend this option for those who use a compatible lens and a compatible flash unit.

Note: If the AF system is unable to find focus, or if you're using manual focus, the camera will automatically switch to pre-flash control. The same will occur with wireless off-camera flash photography, or if you use the non D-series Maxxum/Dynax Macro flash unit. Finally, note that Sony recommends selecting pre-flash control when using filters that reduce light transmission (such as a polarizer) or when utilizing an accessory flash unit's wide-angle adapter (diffuser).

Pre-Flash

This is the standard TTL (through-the-lens) flash metering mode for use with non D-series lenses (or in the circumstances previously noted). With this technology, a brief burst of flash is fired before an exposure is made. The camera's microcomputer analyzes the scene based on the pre-flash to determine the appropriate light output for exposure. Most of your flash exposures will be fine, unless the subject is unusually light or dark, or is located against a very bright or dark-toned background.

Hint: Light subjects and back lighting can lead to under exposure while very dark subjects and backgrounds can lead to over exposure. Check your images on the LCD monitor. If an image would benefit from different flash intensity, set some plus or minus flash exposure compensation (see page 165).

Flash Photography and Camera Exposure Modes

Whether you're using the built-in flash or an accessory unit that's attached to the α100's hot shoe, you can shoot with any of the camera's available exposure modes.

AUTO and Scene Modes

The camera controls the shutter speed and aperture in AUTO and any of the six scene-specific exposure modes. Settings such as ISO, white balance, exposure and flash exposure compensation are set at the camera's default settings. Also, the camera defaults to the *Autoflash* mode, so an activated built-in or accessory flash will fire only in low light or in extreme backlighting conditions. The use of flash in any of these modes is suitable for snap shooting, when you want maximum simplicity.

Note: Remember that the camera's exposure mode determines which of the flash modes can be used. If the exposure mode is set for AUTO, P, or one of the fully automatic scene modes (Landscape, Portrait, etc.), you can use either *Autoflash* or *Fill-flash* (selecting your choice with the Function dial and Fn button). You can only use *Fill-flash* with the A, S, or M exposure modes.

If you do select *Fill-flash* using the Function dial and Fn button in any of the fully automatic exposure modes, the flash will fire for every shot regardless of the lighting conditions. However, if the flash mode default in Recording Menu 2 is set to *Autoflash*, the camera will revert to *Autoflash* mode whenever it is turned off or whenever you switch to any of the other autoexposure modes discussed in this section. You can change the default flash mode from *Autoflash* to *Fill-flash* in Recording Menu 2 For a full discussion of these flash modes, see pages 84-85.

Program (P)

Flash photography in P mode can also be quite simple. The camera's metering system controls the shutter speed and aperture used for each shot. (With flash photography, you cannot use the Program shift feature.) The camera also controls the flash output. However, you can set any desired ISO, flash mode, DRO mode, flash exposure compensation, or other camera function. When you do so, the α100 will not automatically revert to the factory set defaults when it is turned off, as it does when using the AUTO or Scene modes. The camera will also not override the flash mode you selected with the Function dial and Fn button.

Note: In P mode, you can select *Autoflash* or *Fill-flash* as desired, using the Function dial and Fn button. (The *Autoflash* option cannot be selected in A, S, or M mode, however.) If you select *Autoflash*, the camera will only fire the flash when its metering system deems flash to be necessary. If you select *Fill-flash*, it will fire every time regardless of the lighting conditions.

Aperture Priority (A)

In A mode when using flash, you select an aperture. The aperture used determines the flash range. The maximum flash-to-subject distance decreases with each smaller aperture setting. The chart on page 152 shows the range of the built-in flash. If you're using an accessory flash unit with a data panel, it will provide information about the flash range. The camera will set a shutter speed from 1/60 second to 1/160 second, or only 1/125 second when the Super SteadyShot system is on. In low light, the camera usually sets a shutter speed of 1/80 second. *Fill-flash* is the default flash mode and the flash will fire for every shot when the built-in head is up or an accessory flash unit is active. The *Autoflash* mode cannot be selected, even if you set it as the camera's default mode in Recording Menu 2.

When using flash in A mode, the camera does provide a warning if you set an aperture that will produce overexposure. The shutter speed numeral in the viewfinder blinks

before you take a photo. If that happens, set a smaller aperture (such as f/11 instead of f/5.6, for example), or switch to a lower ISO level, until the blinking stops.

The camera does not provide any advance warning that underexposure will occur. If your subject is too far from the flash or a small aperture is used, your flash photos may be underexposed. (This is less of a problem when using a high powered accessory flash unit with a greater effective flash range.) Check your photo on the LCD monitor and set a larger aperture or a higher ISO if it's too dark.

Shutter Priority (S)
When using the built-in or accessory flash in S mode, you select a shutter speed and the camera will set the aperture. You can set shutter speeds as long as 30 seconds and as short as 1/160 second (1/125 second when SSS is on.) The shutter speed cannot exceed the flash sync speed so the camera will not allow you to set a faster shutter speed. *Fill flash* is the default. The *Autoflash* mode cannot be selected.

Changing the shutter speed will not affect the flash exposure. However, it allows you to control how ambient light will be rendered. This is especially useful when you have a flash lit subject in front of a somewhat dark background that you want to be rendered naturally. An example would be your subject in front of a city scene at dusk or a beautiful sunset. If you don't intentionally use a long shutter speed, the picture will probably have a flash lit subject against a very dark or black background.

Make sure you use a tripod when shooting at long shutter speeds to prevent blur due to camera shake. S mode is also useful when you want to render ambient light motion blurs and a sharp flash-exposed subject. You should set the camera for Rear sync (see page 162) and use a long shutter speed to capture the ambient exposure of the moving subject. The camera will produce an image with light trails that follow a sharp subject (illuminated by the brief burst of light).

If the flash exposure of a nearby subject is too dark, set a + flash exposure compensation factor using the Function dial and Fn button. If the flash exposure of a distant subject is too dark, the subject is probably beyond the range of the flash unit. In that case, move closer or set a higher ISO level, increasing the effective flash range. (Digital noise is increased in images made at very high ISO.)

Manual (M)
In M mode when using flash, you set the desired aperture as well as shutter speedup to the top sync speed of 1/160 second (1/125 second when SSS is active.) In other respects, your shutter speed options are the same as in S mode. The *Autoflash* mode cannot be selected. *Fill-flash* is set, firing the flash for every exposure.

Using Manual mode for flash photography provides more creative control. The photographer can adjust the relationship between the flash and ambient light. In Manual mode, the exposure scale in the α100's viewfinder operates, but it only provides a reading for the ambient light in the scene.

If you want the lighting on the subject and the background to be balanced, set the shutter speed and aperture for correct ambient light exposure. If you wish to make an image with a brighter or darker background, you can adjust the shutter speed or aperture. A longer shutter speed provides a brighter background. To set off your subject against a darkened background, use a faster shutter speed or a smaller aperture. (If you close down the aperture, make sure the subject distance is still within the flash range.) Watch the scale in the viewfinder and stop making adjustments when the marker indicates a desired level of difference between subject brightness and background brightness. If the marker on the scale indicates -2 for example, the background will be about 2 stops darker than the subject illuminated by the flash.

The scale provides data in a +2 to -2 EV range. In many typical conditions, the brightness of the background is not substantially higher or lower than the subject brightness, so

the +2 to -2 scale should be adequate. If the background brightness is substantially different than subject brightness—common in very dark locations or with extremely bright backlighting—an arrow at the end of the scale blinks.

Take notice of the flash range especially when using small apertures; the camera provides no advance warning that the settings in use will underexpose the shot. Check your photo on the LCD monitor. If it's dark, set a wider aperture or a higher ISO. When using one of the compatible accessory flash units with a data panel, you'll find useful information about flash range before taking a photo. It varies depending on the ISO, the aperture that you've selected, and the position of the flash unit's zoom head.

Other Flash Options

In addition to selections already discussed, the α100 provides a few other options for flash photography: red-eye reduction, rear flash sync, and slow sync. These are available with both the built-in flash and accessory flash units (provided they support the pertinent feature).

Red-Eye Reduction
Available in Recording Menu 2, this feature mode is recommended for use when photographing people or animals in dark locations. When selected, the flash unit fires several bright bursts intended to reduce the size of the subject's pupils and minimize the red-eye syndrome. (With pets this is often a blue or green effect, but the cause is the same.) After the pre-flashes, the actual flash burst is fired. This feature is occasionally successful in reducing red-eye when used with the built-in flash, but people tend to be annoyed by the bright pre-flashes.

Hint: I do not recommend using Red-eye reduction mode unless you find that the camera/flash produces terrible red-eye in certain circumstances. There are two drawbacks. The bright pre-flashes may cause your subjects to blink or appear unnatural. And there's quite a long delay from the instant that you press the shutter release until the actual exposure is made; during that time, your subjects' expression or position may change.

Effective Ways to Reduce Red-eye:
- Ask the subject not to look directly at the lens.
- Turn up the room lights to cause the iris in the eye to close down reducing the risk of red-eye.
- Use an accessory flash unit that sits higher above the camera, and hence, further from the lens; a greater flash to lens axis distance minimizes red-eye.
- Using an accessory flash unit, bounce the light from a ceiling or wall if your flash unit includes a tilt or swivel head feature.
- Use wireless off-camera flash (see page 164); hold the remote flash unit above and to one side of your subject.
- Use the red-eye correction tool if you have one in your image-processing program.

Rear Sync (REAR)
One of the options available by using the Function dial and Fn button, Rear sync causes flash to fire at the end of an exposure, and not at the start of an exposure as in conventional flash photography. When used for shooting moving subjects at long shutter speeds (preferably 1/15 second and longer), this feature produces the effect of motion streaks that follow the subject instead of preceding it. Some photographers also use rear sync for long exposures of static objects or people, moving the camera to produce interesting flash blur effects.

Motion Blur—How It Works
In order to create motion trails that follow an object, the flash must be fired at the end of the exposure with Rear sync. If the flash is fired using the standard flash mode

(front curtain sync), the moving object is "frozen" at the beginning of its travel and then the motion trail is recorded. This captures the action but the motion trail appears to be in front of the moving object. However, if the flash fires just before the shutter closes, the camera will record the ambient light motion blur and then freeze the object. Thus, the photo will appear natural, with the motion trail following the object. This technique can produce dramatic action shots, so take the time to experiment with your camera and flash until the effects you want become second nature.

Slow Sync

You can set a long shutter speed using S or M mode for flash photography, or use Slow Sync and the α100 will set a long shutter speed in any other exposure mode. When flash is on, simply press and hold the button marked AEL/SLOW SYNC (on back of camera in upper right corner). That will cause the camera to set a long shutter speed. (The exact speed depends on scene brightness and the ISO setting.)

This function can be useful when taking photos of a nearby subject lit by flash against a distant, not excessively dark, background. For example, use this setting to photograph a person with a nighttime cityscape in the background. The long exposure time will record the ambient light in the scene without affecting the flash exposure. Use a tripod to avoid blur from camera shake and have your subject remain still during the entire exposure.

Wireless/Remote Flash

Wireless/remote flash applies when using one of more of the following units: Sony HVL-56AM, Sony HVL-36AM, or Maxxum/Dynax HS(D)-series. You can take flash photos with the accessory flash unit positioned off-camera. There is no need to use an optional TTL off-camera cable to connect the flash unit to the camera's hot shoe.

163

Select the WL (*Wireless*) option using the Function dial and Fn button. Mount the accessory flash in the camera's hot shoe and turn both the α100 and the flash unit on. Now, remove the accessory flash unit from the camera and pop up the built-in flash head. When you take a photo, the off-camera flash will be triggered by a brief burst of light from the built-in flash. Metering control is TTL, making it quite easy to get good exposures without any calculations.

Wireless/Remote Flash Techniques

When the accessory flash unit is charged and ready, its AF illuminator lamp blinks twice, indicating that you can take the photo. The built-in flash will fire a low intensity burst, just enough to trigger the remote flash but not enough to light the subject. High-speed sync (HSS—see page 166) can be used in wireless flash photography with the α100. Just remember that this feature reduces the effective flash range, especially at very fast shutter speeds.

Initially, practice with a single remote flash unit. If you own two HSS compatible flash units, try more advanced setups with one illuminating the subject and the other illuminating the background. Just make sure that both remote units maintain line of sight with the on-camera flash. To be certain, take a test shot

Flash Range: Wireless flash photography works best indoors, in a location that is not excessively bright. It's important to position the remote flash unit so it's not too close to, or too far from, the subject. As well, the remote flash should not be too far from the camera; otherwise, it may not be triggered.

The remote flash to subject distance should be no less than one meter (or 3.3 feet). The maximum distance between flash and subject will vary depending on the power of your flash unit. It will also vary depending on the aperture you have set on the camera. When shooting at f/5.6, for example, using ISO 100 and a normal 1/160 second or 1/125 second, place the flash unit no further than 5 meters (16.4 feet) from the subject.

Note: When you return to conventional flash photography, do not use the camera's wireless flash mode. Select one of the other flash modes, using the Function dial and the Fn button. If you forget to do so, flash exposures may be incorrect.

Modifying Flash Intensity

Regardless of the flash options or shooting techniques used, you may well find that some exposures exhibit more or less flash than you want. After taking any flash photo, review the image on the camera's LCD monitor. If you prefer more or less flash intensity, simply set flash exposure compensation.

Flash Exposure Compensation 🔅

Particularly in outdoor photography, you may find that you prefer a more subtle fill-flash effect than the system produces. If so, select 🔅 using the Function dial and Fn button. Try setting a -1 flash exposure compensation factor to reduce flash intensity. Re-shoot and examine the more subtle flash effect. For more intense flash (sometimes necessary to prevent underexposure caused by a white subject or an extremely bright background), try a +1 flash exposure setting. The amount of compensation that is ideal will vary based on the subject, lighting conditions, and your personal preferences. The only adjustment made is to the amount of light output by the flash. The aperture and shutter speed settings do not change when flash exposure compensation is used, so ambient light exposure is not affected.

Using Flash with Exposure Compensation 🔆

In some situations, you may want to use exposure compensation to adjust flash output as well as ambient light exposure or to adjust only ambient light exposure and not flash output. To do this, you would use the α100's exposure compensation feature. There are two possible settings found in Custom Menu 1. *Ambient & flash* (the default) applies the set compensation amount to both the ambient light and flash exposure by adjusting the aperture, shutter speed, ISO (AUTO exposure mode only), and flash output. If your entire

165

image is too dark or too light, try using this exposure compensation setting. The *Ambient only* setting adjusts the aperture, shutter speed, and ISO (AUTO mode only) to affect the background exposure, but not the flash exposure. Use this setting to brighten or darken the background without changing the flash exposure.

These concepts are important to learn if you want to control exposure for the subject, for the background, or for both. Experiment with simultaneous use of the camera's ambient light and flash exposure compensation features. Try different levels for each and check the resulting images on the camera's LCD monitor. With some experience, you'll soon become adept at estimating what settings will produce the most accurate, or creatively pleasing, exposure for the subject and the background in flash photography.

High-Speed Sync (HSS)

A feature that's available only with the Sony HVL-F56AM and HVL-F36AM or the (discontinued) Maxxum/Dynax HS(D)-series flash units, High-speed sync (HSS) mode allows the flash to sync at shutter speeds faster than the normal 1/160 second sync speed of conventional flash photography. HSS is set on the flash unit and allows you to take flash photos at shutter speeds as fast as 1/4000 second. Instead of firing a single burst of light when the shutter is open, HSS fires short, lower intensity bursts as the curtain travels across the image plane.

Fast shutter speeds are associated with stopping subject motion, so that people may mistakenly think High-speed sync is for photographing moving objects with flash. It is not. This setting is useful when you want to use flash for a subject in bright sunlight, especially with a large aperture (such as f/2.8). When using flash at the conventional 1/160 second sync speed, it is likely the image would be overexposed. Using a fast shutter speed controls only the bright ambient light exposure and prevents it from overpowering

the flash exposure. By making the photo with a faster sync speed, such as 1/500 second, you can correctly expose for the ambient light and flash.

To utilize HSS, attach a compatible flash unit to the camera's hot shoe and set it to the HSS mode. Note that HSS cannot be used when REAR (*Rear sync*) or the one of the self-timer options has been set on the camera. High-speed sync works in the camera's A, S, and M modes, when a correct ambient light exposure calls for a shutter speed faster than the normal 1/160 second sync speed, but it's most convenient in S mode.

When experimenting with HSS, select the α100's Shutter Priority (S) mode and set a desired shutter speed, such as 1/500 second. Check the information on the flash unit's data panel as to flash range. (At high shutter speeds, flash range is very short unless a high ISO level has been set.) If the range is not suitable for the camera-to-subject distance, select a different shutter speed and check the data panel again. Setting a higher ISO level in the camera can increase the effective flash range at any shutter speed.

Although you can select shutter speeds (sync speeds) as fast as 1/4000 second, you'll rarely need to use anything faster than about 1/500 second. The flash unit's guide number is dramatically reduced when you use HSS as you select faster shutter speeds. This limits the flash range. Unless you're using a very high ISO setting for extreme close-ups in very bright sunshine, a sync speed of 1/250 second to 1/500 second will often be perfect when shooting at wide apertures.

Bounce Flash

Direct flash can often be harsh and unflattering, causing heavy shadows or a "deer in the headlights" appearance in your subject. Bouncing the flash diffuses the light to soften it and create a more natural-looking effect.

Most compatible accessory flash units feature heads that are designed to swivel and tilt, although some only allow for tilting upward. Either type can be useful for allowing a shoe-mounted flash to be adjusted so it is not aimed directly at the subject. You can point the flash toward the ceiling at a point about halfway between the flash and the subject. If the head also swivels, you can point it toward a wall beside the subject. Either technique can produce softer lighting. However, the ceiling and walls must be white or light gray or they may cause an undesirable color cast.

Note: When you bounce flash, the LCD data panel will show the effective flash range. Nor is such data published in owner's manuals because it depends on the distance from the camera to the bounce surface plus the distance to the subject. As a rough estimate, assume that flash range is about half of what it would be with direct flash photography. It can be greater than that if the bounce surface and subject are quite close, or less if the subject and/or the surface is very far from the camera or each other. After taking a photo, check the LCD monitor. If it's too dark, use a larger aperture or select a higher ISO setting to increase the effective flash range.

Bouncing the flash from a ceiling or a wall will spread the illumination, eliminating the harsh shadows and red-eye that often result when using direct flash. ⇨

Lenses and Accessories

Sony markets two distinct series of lenses: Sony G, which are re-badged and re-styled Maxxum/Dynax models, and the entirely new Carl Zeiss Alpha (ZA) T* lenses. (The abbreviation T* refers a special multi-layer coating for flare control, proprietary to Carl Zeiss.) The latter are high-end optics with large maximum apertures, very rugged construction, and premium-grade optical engineering.

Sony does not guarantee full compatibility with other brands of lenses, but the α100 is compatible with Konica Minolta Maxxum/Dynax lenses and should work with many aftermarket lenses with that mount. Do note, however, that the Super SteadyShot (anti-shake) system will not work with two Maxxum/Dynax lenses: the 16mm f/2.8 Fisheye and the Zoom 3x–1x f/1.7–2.8 Macro. However, in other respects, those two should be compatible with the α100.

Some Maxxum/Dynax lenses, and some aftermarket models with a compatible mount, are labeled D-type. The D denotes a distance-encoding device (in the lens barrel) that allows the camera to make improved calculation for flash exposure (ADI) when using the built-in flash or an accessory D-series Maxxum/Dynax flash unit. All of the current and future Sony G and ZA lenses include the distance-encoding device for maximum compatibility with the α100, but Sony has not labeled these lenses with the D designation.

Commonly used for wildlife and sports photography, telephoto lenses bring you close to the action and isolate the subject. This bike racer was photographed with a zoom lens at a focal length of 300mm, which is equivalent to 450mm when mounted on the α100.

Effective Focal Lengths

If the sensor in a digital camera is smaller than the size of a 35mm film frame (24 x 36 mm), the field of view with any lens will be narrower than if that same lens were place on a 35mm camera. The smaller sensor is responsible for this field-of-view crop. In practice, this crop gives the lens a view that has more "telephoto effect" than it would on a 35mm camera. The result is sometimes referred to as the effective focal length.

This telephoto effect occurs with the α100, since its sensor (23.6 x 15.8 mm) is smaller than a 35mm film frame. For comparison purposes, the effective focal length of a lens used on the α100 is increased by 1.5x in order to understand the view one gets. For example, images made with a 20mm lens on the α100 will look like images made with a 30mm focal length on a 35mm camera. A 300mm telephoto produces the view that we would expect from a 450mm lens.

That's great news if you appreciate sports and wildlife photography, where the α100 used with even a moderate telephoto lens can now produce frame-filling images of distant subjects. But it's less than ideal if you prefer wide-angle landscape or travel photography, with images that include scenic vistas. Fortunately, you can find short focal-length lenses such as the Sony 11–18mm f/4.5–5.6 G zoom that produces the view that 35mm film photographers would expect from a 16.5–27mm zoom. In future, expect to see additional lenses with short focal lengths for ultra wide-angle photography with the α100.

Note: Unless otherwise indicated, lenses will be referenced by their actual focal length, not their effective focal length.

Selecting a Lens

Think hard about your specific photographic needs before spending money on lenses. The focal length and design of a lens will have a huge affect on how you photograph. The

The long end of a 75-300mm zoom gives you the reach you want at a comfortable distance.

right lens will make photography a joy; the wrong one will make you leave the camera at home.

One approach is to determine if you are frustrated with your current lenses. Do you constantly want to see more of the scene than the lens will allow? Then consider an ultra wide angle lens such as the 11-18mm model. Or maybe the subject is often too small in your photos because it is far from the camera. Then look into acquiring a telephoto lens such as the 75-300mm model.

Portraits look great when shot with focal lengths between 60 and 90mm, although some photographers appreciate the effects produced by a 135mm lens. Interiors often demand wide-angle lenses. Many people also like wide-angles for landscapes, but telephotos can come in handy for isolating the most appealing elements of a distant scene.

Normal Lenses

The focal length of a normal lens corresponds to the diagonal of the format. With 35mm film, this measurement would be exactly 43.3 mm; but for design reasons, most normal lenses for 35mm SLRs are about 50mm. Because of the α100's sensor size, a focal length of about 35mm becomes equivalent to the view of a standard lens placed on a 35mm camera. Thus, a lens like Sony's 35mm f/1.4 G, used on the α100, becomes a normal lens because it has an effective focal length of 52.5mm (35 mm x 1.5). And a 50mm lens on the α100 would have an effective focal length of 75mm, becoming a short telephoto.

With a 35mm lens mounted on the α100, subjects in the viewfinder appear about the same size as they look to the naked eye. For most amateur photographers, a normal lens is adequate for many subjects, as long as you get close enough to (or far enough away from) your subject. However, if you want to achieve a closer view without moving physically closer to your subject, for example a horse in a field, you will need to use longer lenses. Conversely, if you want to photograph a sweeping vista or a group of people inside a small room, a shorter focal length will give you a wider field of view.

Telephoto Lenses

Lenses with focal lengths that are greater than a normal lens are called telephotos. In the case of the α100, this would be any lens with a focal length greater than 35mm. They allow us to bring distant subjects "closer." Lenses with focal lengths just beyond normal (35mm to 50mm) are in the short-end range of telephotos.

These riders appear as though there is no space between them, *heightening the drama of the race. In reality, they aren't quite as close to each other as they look. Longer telephoto lenses not only magnifying distant subjects, they also produce compressed perspective, as illustrated here.*

Telephoto lenses have several interesting characteristics. The longer the focal length, the more obvious these characteristics are. Long lenses compress perspective, reducing the apparent distance between objects in a scene. This is useful for creating interesting effects such as stacking near and distant hills in haze or making a traffic-filled city street look especially congested.

A telephoto's narrow angle of view often limits the number of components that can be included in the image, eliminating clutter. In high magnification photography, depth of field is very shallow, so only the focused plane is sharp; that's useful for blurring away a distracting background, particularly at a wide aperture (small f/number). This makes a telephoto lens an excellent tool for isolating a subject and making it "pop."

Moderate Telephoto Lenses

These are lenses from about 50mm through 135mm on the α100. They often feature larger maximum apertures than longer lenses. In the Sony system, lenses of this type include the 50mm f/1.4 G and 135mm f/2.8 G, as well as the 135mm f/1.8 Carl Zeiss Alpha T* model. All three, particularly the Zeiss Alpha lens, are premium-grade products and are large and heavy due to their wide apertures and rugged construction. Lenses on the lower half of this range are regarded as excellent portrait lenses.

Longer Telephoto Lenses

With the α100's smaller sensor, even moderately long telephotos such as the 75-300mm f/4.5-5.6 G zoom will give you quite a bit of reach (450mm equivalent at the long end). Sony also offers larger, pro caliber telephotos such as the 70-200mm f/2.8 G zoom and the 300mm f/2.8 G. Large maximum apertures make these useful in low light because they allow the camera to set fast shutter speeds with less need for high ISO levels.

Lenses with focal lengths of 300mm or longer move your view much closer to your subjects than shorter lenses and allow for creative shots using the compressed perspective.

The increased subject magnification and size of these lenses often exaggerate camera shake, but the α100's Super SteadyShot system is helpful in reducing this.

If you want a lens with an extremely long focal length, the Sony 500mm f/8 G Reflex Mirror lens (750mm equivalent) might be worth considering. It is surprisingly compact and relatively affordable because it employs a different type of technology called "catadioptric," indicating that mirrors extend the light path, making the barrel unusually short. However, the only available aperture is f/8, and that is quite small. Consequently, this lens is not ideal for low light photography unless you are prepared to work at very high ISO levels or use a sturdy tripod to prevent camera shake when shooting at the longer shutter speeds required with f/8.

Wide-Angle Lenses

Wide-angle lenses produce a broad field of view and "expanded spatial perspective." Foreground elements become prominent while more distant objects are "pushed back," rendered smaller than the eye perceives. You can exploit this trait with a variety of subject matter, including cramped interiors, yachts at a marina, or land and cityscapes. Depth of field is also extensive, so an entire vista can be rendered in reasonably sharp focus at almost any aperture.

If you use a focal length of 18mm, the equivalent focal length becomes 27mm—a wide, though not ultra wide view, that is often ideal for point-and-shoot photography. When trying to fit as much of a scene into your picture as possible, or while working in limited space, an even wider angle may be a better choice. That's why Sony markets the 16mm f/2.8 G lens and the 11–18mm zoom.

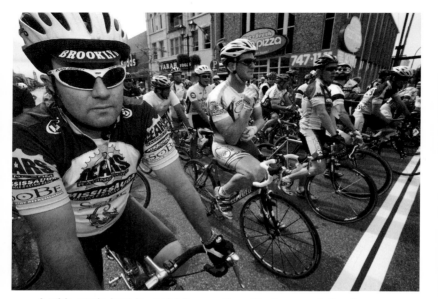

A wide-angle lens is useful for creative effects, especially when you move in close to a primary subject. This picture, shot using a focal length of 17mm, draws your attention to the man at left while still giving a look at the competition.

Understanding the Fine Points of Lenses

Composed of various types of multiple elements, lenses focus light rays on a common point: a sensor in a digital camera or film in a conventional camera. But lenses have several other essential functions. They control the amount of light that will make an exposure, the range of acceptable sharpness within a scene (depth of field), the focus, the subject magnification, and the angle of view (the amount of any scene which will be included in the image).

Large vs. Small Maximum Apertures

Some lenses feature a wide maximum aperture such as f/2.8, while others have smaller maximum apertures such as f/5.6. Many zoom lenses have variable maximum apertures. For example, the 75-300mm f/4.5-5.6 G zoom has a maximum

aperture of f/4.5 at its short end that diminishes gradually as you zoom to longer focal lengths. By about the 250mm setting, the maximum aperture is f/5.6. By comparison, a pro caliber zoom, such as the 70-200mm f/2.8 G, is very "fast." Its f/2.8 maximum aperture is constant through the zoom range and allows the camera to set faster shutter speeds at any ISO level.

A wide aperture lens—whether f/1.4 or f/2.8—can be useful, but the trade-off is significant. The 70-200mm f/2.8 G is much larger and heavier than the 75-300mm f/4.5-5.6 G model, and it's also a lot more expensive. That's why most lenses (in all brands of camera systems) feature moderately small to very small maximum apertures; these types outsell large aperture lenses by a very wide margin.

Zoom Lens Pros and Cons
When zoom lenses first came on the market, they were not equivalent to single-focal-length lenses in terms of resolution, color rendition, or contrast. Today, you can get superb image quality from either type.

The best feature of a zoom lens is versatility. A single zoom can replace four or five other lenses, making for greater convenience and portability, but they do have some limitations when compared to lenses with a single focal length.

The most important drawback to zoom lenses is smaller maximum aperture(s). Except for a few "fast" (f/2.8) professional models, most zooms are slower, featuring smaller maximum apertures. Consequently, you'll need to use a higher ISO setting for a fast shutter speed, and the images may exhibit more visible digital noise.

Note: Small maximum aperture is less relevant when shooting with the α100, at least in terms of the shutter speeds required to prevent blur from camera shake. When using the Super SteadyShot function, there is less need for fast shutter speeds. Still, in dark locations, and in action photography, the faster shutter speeds available when using a "fast" lens are certainly beneficial.

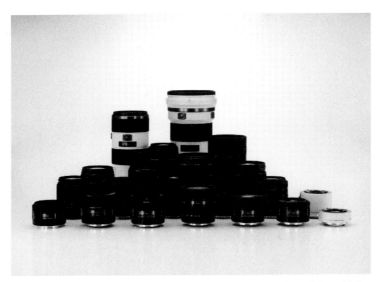

In addition to the Sony G series, Sony markets Carl Zeiss Alpha lenses for the ∝100, but the camera also accepts the full range of Konica Minolta Maxxum/Dynax lenses. Photo courtesy of Sony Corporation.

Few long zooms feature a maximum aperture of f/2.8. If you need a lens with a maximum aperture of 2.8 and a longer focal length than 200mm, you would need to buy a fixed focal length such as the 300mm f/2.8 G (450mm equivalent). Konica Minolta made a Maxxum/Dynax 600mm f/4 super telephoto that is compatible with the α100. For most photo enthusiasts, lenses that combine wide maximum apertures and long focal lengths are prohibitively expensive and excessively large and heavy.

High Tech Glass
Some of the wide aperture Sony G telephoto and zoom lenses incorporate special glass elements called "low dispersion" or "anomalous dispersion." These modify the way that light rays are bent, producing superior color rendition as

well as higher sharpness across the entire image frame. The benefits are most obvious in images made at large apertures and long focal lengths.

An increasing number of wide-angle lenses, including some of the Sony G zooms and Carl Zeiss Alpha single focal length lenses, incorporate element(s) with a non-spherical surface. Such "aspherical" lenses boast reduced flare, more consistent sharpness across the frame at large apertures, and less bending of straight lines near the edges of the image. A single aspherical element can take the place of two conventional elements, reducing size and weight of the lens.

Ultrasonic Focusing Motor

Two of the pro-caliber Sony G lenses, the 300mm f/2.8 G and 70-200mm f/2.8 G, are designated as SSM, for Super Sonic wave Motor, indicating an ultrasonic focus motor. The primary advantages are quieter operation and excellent starting/stopping response. The SSM lenses also include two Direct Manual Focus (DMF) modes: Standard DMF and the newer full-time DMF. The latter allows manual focus adjustment (while in autofocus mode) at any time, even if the AF system has not yet acquired focus.

ADI Compatibility

All of the Sony G and Carl Zeiss Alpha lenses (as well as D-series Konica Minolta Maxxum/Dynax lenses) incorporate a distance encoding chip that is required for full compatibility with ADI (Advanced Distance Integration) flash metering. This metering system is less influenced by subjects of high reflectance (such as a bride in a white gown) or low reflectance (such as groomsmen in black tuxedos). By combining subject distance into the equation for a correct flash exposure, the ADI system can produce better results when using the built-in flash or a D-series Program flash. (When a conventional Maxxum/Dynax lens is used, the camera employs the older, conventional Pre-Flash TTL flash metering system.)

Digital Optimization

All of the Sony G and Carl Zeiss Alpha lenses (as well as dis-continued Maxxum/Dynax D-series lenses) are optimized for use with a digital SLR camera. Digital optimization mini-mizes vignetting (darkening at the corners), maximizes sharpness near the edges of the frame, and prevents internal reflections that can cause flare. These are especially advan-tageous when using wide-angle lenses with digital cameras at apertures larger than f/8.

Do note that the Sony G and Alpha lenses fall into two categories. Most are "multi-format," compatible with both 35mm SLR and digital SLR cameras. However, some lenses were designed exclusively for use with a digital SLR (such as the α100). The latter include the Carl Zeiss Alpha T* 11-18mm and three Sony G zooms: the 11–18mm, 18–70mm and 18–200mm models.

In the Maxxum/Dynax line, lenses designated with DT can only be used with digital SLRs. If a lens designed exclusively for a digital SLR is used on a 35mm camera, the corners of the image will be black because these lenses do not project an image circle that covers the larger 35mm film frame.

Close-Up Photography

Some Sony telephoto zoom lenses allow for close focusing in order to render a small subject about 1/4 life-size on the image sensor (also called 0.25x magnification, or a 1:4 reproduction ratio). However, Sony also makes true macro lenses that produce a life-size rendition (1:1 reproduction ratio) at the closest focusing distance. Thus, a honey bee will be exactly bee-sized on the digital sensor, without the need for magnification.

Sony offers two true macro lenses: the 50mm f/2.8 G and the 100mm f/2.8 G. The longer macro lens is most useful in nature photography because it provides high magnification at a greater focusing distance. This eliminates the need to be extremely close to a skittish subject, such as a butterfly.

If you want to photograph flowers, bugs, or your coin collection, you have several equipment options. These include close-focusing zooms, extension tubes, or close-up accessory lenses (filters). The best choice, however, is a true macro lens such as the Sony 100mm f/2.8 Macro. While it is pricey, this bright (f/2.8) lens can be used for both macro work and standard telephoto photography.

Close-Up Accessories

If you don't own a lens that allows for extremely close focusing and you cannot justify the cost of a true macro lens, check out two types of devices that are available.

Magnifying Filters

Resembling magnifying glass in a filter mount, a "close-up filter" or "plus diopter" is ideal for use with telephoto zoom lenses. Simply screw it into the front threads of the lens as you would with any type of filter. This type of accessory is not available from Sony but is sold by various filter manufacturers. For the best image quality, look for models that are "achromatic" (highly-corrected, multi-element lenses).

Extension Tubes

Available from aftermarket manufacturers, extension tubes are hollow tubes without any optical elements. They fit between the lens and the camera, and move the optical center of the lens farther from the sensor. This allows the lens to focus much closer than it could normally. Automatic extension tubes (dedicated to Maxxum/Dynax cameras and hence to the Sony camera) maintain the camera's automatic functions. They are designed to work with all lenses for your α100, but are most suitable for fixed focal length lenses.

Be aware that extension tubes do cause a considerable light loss and, in general, should only be used with a camera that is on a tripod or other support. The camera's light metering system compensates for this loss of light by selecting a longer shutter speed, but with longer tubes, you may need to use a higher ISO setting.

Hint: Though relatively expensive, true macro lenses are a good investment for anyone who often needs extremely close focusing capability. Such lenses are designed for superb sharpness at all distances and will focus from mere inches to infinity. In addition, they are typically optimized for flat-field photography. If you do not often need that capability, buy a quality close-up filter for a zoom lens or a 50mm extension tube for a fixed focal length lens.

Whether using a macro lens or accessories, depth of field is extremely shallow at close distances. The range of acceptable sharpness may be only a centimeter or two. Anything outside the depth of field will be unsharp to some extent. Do not confuse this effect with poor optical quality. For greater depth of field, use a small aperture such as f/16. Focus manually, with extreme care, on the most important subject element: the eyes of an insect, for example. After taking a shot, review it on the LCD monitor, using the magnify feature; if the focus or depth of field is not correct, re-shoot after modifying focus or selecting a smaller aperture.

Due to the higher magnification at extremely close focus, even the slightest camera movement or subject movement will produce an unsharp image. Use a tripod and an ISO setting that will provide a moderately fast shutter speed of at least 1/125 second, if possible.

Other Lens Accessories

Teleconverters

A teleconverter is an optical attachment consisting of a group of elements in a tubular mount. It is placed between the camera body and the lens, and it effectively increases the focal length of the lens in use.

Inexpensive versions are available from aftermarket manufacturers, but Sony offers two premium quality teleconverters for the α100: the 14 TC and the 20 TC. The 14 TC extends a lens' focal length by a factor of 1.4x, and the 20 TC does the same by a factor of 2x. They are an alternative to the steeper investment often required to purchase top-quality telephoto lenses.

Both of these converters are compatible with the Sony 70-200mm f/2.8 G, Sony 300mm f/2.8 G, and the Sony 135mm f/2.8 STF lenses. In addition, they can be used with the Maxxum/Dynax APO G-series of fixed focal length lenses ranging from 200mm to 600mm. Sony's two teleconverters are not recommend for use with other lenses.

While increasing the reach of your telephoto or zoom lens, be aware that teleconverters reduce the amount of light that reaches the image sensor. A 1.4x converter will cause a 1-stop loss of light, while a 2x leads to a 2-stop loss.

Protective Filters

Some photographers buy haze or skylight filters to protect the front lens element from scratches. After all, a filter is less expensive to replace than a damaged lens element. A protective filter can also be useful in such conditions as strong wind, rain, blowing sand, or when going through brush. If you do use a filter for lens protection, a high-quality filter is best, preferably one that is multi-coated to reduce flare. An inexpensive filter can degrade image quality. Remove any filter when shooting toward the sun to minimize the risk of flare.

Graduated Filters

Because the color balance of an image can be controlled by white balance settings, photographers rarely need color balancing filters. A filter that is useful in digital photography is a graduated neutral density filter, or ND grad. Half of the filter is clear while the other half is dark (gray.) It is often used in landscape or cityscape photography to reduce bright areas (such as sky), while not affecting darker areas (such as the ground).

Square or rectangular ND grad filters are convenient. When used with a filer holder designed for them, these filters can be moved up and down until the center lines up with the horizon in the scene.

Polarizing Filters

I strongly recommend the circular polarizer, preferably a multi-coated model of high optical quality. By blocking polarized light reflected from water droplets and particles in the air, this accessory can deepen the tone of a blue sky. A polarizer also reduces glare from non-metallic subject surfaces for richer, more saturated colors.

Note: There are two types of polarizers, "circular" and "linear." They look identical and produce the same result but use different technology. The α100 requires a circular polarizer for correct exposure and accurate autofocus.

As you rotate the polarizer, watch the effect—richer sky colors for example—through the camera's viewfinder. A polarizer works best when the sun is at a 90° degree angle to your position. If the sun is directly behind you, or if you are shooting directly into the light, a polarizer won't have any effect. But if the sun is to the side, or directly overhead, the filter will work its magic effectively.

Lens Hood

Sometimes called a lens shade, this short tube attaches to the front of the lens and reduces glare by blocking undesirable light from reaching the lens. It also offers protection to the front of the lens.

Camera Support Accessories

If you want to get the most from your Sony camera and lenses, be aware that camera movement affects sharpness significantly, causing image blurring. While the anti-shake system allows us to use longer shutter speeds in hand-held shooting, it cannot perform miracles. A rigid tripod is an essential accessory when you cannot use fast shutter speeds, when shooting with longer telephoto lenses, and for close-up work. By holding the camera/lens rock steady, it can assure sharp images.

Hint: When the camera is mounted on a tripod, consider using an electronic cable release. Two models are available: the Remote Commander RM-S1AM with a cable length of 19.75 inches (0.5 meters), and the longer RM-L1AM with a cable of 39.5 inches (1 meter).

When using a cable release, you can set the camera's self-timer for a 2-second delay, although that technique does not allow for taking a shot at the perfect instant in sports and wildlife photography.

A solid tripod head that will maintain stability while providing full versatility in camera positioning is essential. This head from Manfrotto offers gear-controlled movement and a quick release feature that lets you easily secure and remove the camera. Photo courtesy of Bogen Imaging.

Tripods are the most commonly used camera stabilizing device, but beanbags, monopods, mini-tripods, shoulder stocks, and clamps can be useful too. Many photographers carry a small beanbag or a clamp pod for those situations where a tripod isn't practical. A good tripod is an excellent investment. A cheap tripod can actually be wobbly and cause more problems than it solves. When buying a tripod, extend it all the way to see how easy it is to open, then lean on it to see how stiff it is. Both aluminum and carbon-fiber tripods offer great rigidity. Carbon-fiber is much lighter, but also more expensive.

A long shutter speed, in this case 1 second, was used to produce this "silky" effect in a flowing waterfall. © Kevin Kopp

The tripod head is an important consideration and may be sold separately. There are two basic types for still photography: the ball head (my favorite) and the pan-and-tilt head. Both designs are capable of solid support. The biggest difference between them is how you loosen the controls and adjust the camera. Try both and see which seems to work better for you. Be sure to do this with a camera on the tripod because that added weight changes how the head works.

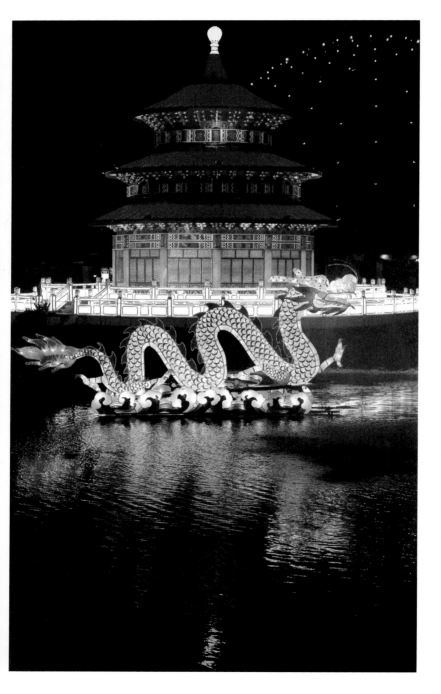

Working with Images

Taking great pictures with your α100 is only one component of the digital photography experience. You may also want to download images to a computer, convert RAW files, file and store your photos for easy access and viewing, enhance them using image-processing programs, and make prints.

Image Data

A wealth of information is recorded when you shoot a digital picture with the α100. This data is stored in the Exchangeable Image File Format (EXIF—often called by the generic term of Metadata).

This EXIF data embedded with the image file includes: date and time of recording, aperture, shutter speed, ISO, exposure mode, metering mode, lens focal length, white balance setting, color mode, exposure or flash compensation, and settings for color saturation, contrast, or sharpness. Some of this information will be used by the printer in direct printing, as discussed on pages 203.

You can examine some of the EXIF data on the camera's LCD monitor. You can also review all of it using the Sony Picture Motion Browser (compatible only with Windows operating systems) or with other imaging software. It's worth occasionally checking all of the data as a reminder of the camera settings that you used. Compare pictures and data to learn more about exposure, depth of field, the depiction of motion, flash exposure, and so on.

↺ *Your α100 records useful data about the settings used to shoot your photos, including the f/stop, shutter speed, ISO, exposure mode, and more. By studying this information in relation to the way your image looks, you can learn a great deal about how these settings affect the quality of your image.*

Downloading Images

There are two main ways of getting digital files off the memory card and into your computer. One is to use an accessory card reader that downloads the files from your card. Another is to download images directly from the memory card in the camera using the USB cable included with your α100. Direct downloading eliminates the need to buy a card reader, but it means you have to get your cable and connect (then disconnect) the camera to the computer each time you want to download, while a card reader simply remains connected and ready to use at all times. Also, downloading directly from the camera consumes a great deal of battery power, which is one argument for using optional AC Adapter AC-VQ900AM.

Memory Card Reader

A memory card reader is a simple desktop device that plugs into your computer either using USB or FireWire connection. Card readers usually read one particular type of memory card, or can be designed to accept several different kinds of cards. The latter can be useful if you use both Memory Stick Duo cards (with an adapter) and CompactFlash cards with your α100, or if you own another digital camera that uses a memory card of some other format.

After you have connected the card reader to your computer, put the memory card into the appropriate slot. The card should appear as an additional drive on Windows XP and Mac OS X operating systems; for other operating systems you will probably have to install the drivers that come with the card reader. Select your files from the card reader and drag them to a preferred computer drive and folder.

PC Card Adapter

If you use a laptop, especially when traveling, you may prefer an alternative to the card reader known as a CompactFlash PC card adapter. This device is compatible with

any laptop's PC card slot. Insert the memory card into the CompactFlash PC card adapter. Then, insert the adapter into your laptop's PC card slot. The computer will recognize this as a new drive, and then you can drag and drop images from the card to the desired folder in your computer's hard drive.

Hint: Most PC card adapters use the 16-bit standard, but several companies make 32-bit PC card adapters, sometimes called Cardbus 32 Adapters. These can take advantage of internal bus speeds that can be four-to-six times faster. The 32-bit accessory costs three or four times more, but it's great when you have large image files to download to a laptop computer.

Direct from the Camera
Make sure to use either a fully charged battery or the optional AC Adapter. Turn the camera on to make sure the *Transfer Mode* option in Setup Menu 1 is set for *Data storage* (see page 95). Now, be sure to turn the camera off before taking the next steps.

You must use a computer with a USB port and USB interface support. USB connectivity must be installed if your computer does not include it. As well, your PC must use Windows ME, 2000, or XP. If you own a computer with a Mac OS X operating system, you can download images from the camera but you will not be able to use the Sony Picture Motion Browser, because it is not Mac compatible. For additional specifics about compatibility, check the latest information available at www.sony.net .

With the α100 powered off, plug the supplied USB cable into the terminal under the card slot cover on the right side of the camera. Plug the other end into your computer's USB port (to prevent possible problems, do not attach to a USB hub.) Turn the camera on and look at the LCD monitor to confirm connection. Data transfer will then begin.

If you're using Windows XP or Mac OS X, a window may appear on your computer monitor designed for downloading images; follow the instructions it provides. An icon should also appear designating the camera as a drive, for example, "Removable Disk (D:)." If the latter does not appear, disconnect the camera and start the process over.

With Windows based computers, the Sony Picture Motion Browser should launch automatically; you can then designate the folder in your computer where the images should be sent. With Mac computers, you will need to drag and drop images from the DCIM folder to the desired folder in your computer. You can do the same with Windows based computers if you do not use the automated Picture Motion Browser feature.

Double click on the DCIM folder to reveal the specific files in the folder. (The "Misc" folder contains data that may be required for DPOF printing, discussed later in this chapter.) Do not change the names of any folder or file. To copy images simply drag and drop the file icons to a location in your computer, such as "C: My Pictures." Be sure to specify Copy instead of Move.

Note: A .jpg suffix indicates a JPEG image, which can be read and manipulated by nearly all imaging programs. The .arw suffix indicates a RAW file. You can download these, but later you'll need to use special software to convert them to another format, most likely JPEG or (preferably) to TIFF. (To use Sony's Image Data Converter SR, you need Windows ME, 2000 or XP for PCs; with a Mac you must be running OS X 10.1.3 or later). You can also use other RAW-compatible programs, such as Adobe Photoshop CS2 or Adobe Elements 3.0 (or later versions of each; you will need to download from Adobe's website the version of Adobe Camera Raw plug-in that supports Sony ARW files from the α100—install the plug-in exactly as specified by Adobe).

Caution: Never disconnect the camera or switch to a different memory card while the camera's red access lamp is lit. If you do, data will be lost and the memory card may be permanently damaged.

After downloading is complete, the red access lamp on back of the α100 stops lighting. Switch the camera off and disconnect the USB cable. If your Windows system requires that you first "Stop Mass Storage Device," be sure to follow the "Unplug" or "Eject" hardware routine before unplugging the camera or switching to a new memory card. Start by clicking the Unplug or Eject icon located in the task bar. Follow the procedure required to unplug or eject the pertinent device (camera) before unplugging it or removing the memory card and inserting a new card. If using a Mac computer, drag the mass storage device icon for the camera into the trash.

When finished turn off the camera and unplug it. If you only want to download files from another memory card, do not disconnect the camera, just turn it off. Then change memory cards and turn the camera on again to reestablish the USB connection.

Picture Motion Browser

Compatible only with Windows ME, 2000, and XP, (not with Mac operating systems), this is an uncomplicated program that includes a basic browser and a few essential image adjustment options. (A full Help menu is available when you click on Help, or the menu icon at the top of the screen.) Full (EXIF) shooting data can be displayed by right clicking on an image that's displayed in the browser screen and selecting Image information.

Picture Motion Browser possesses a variety of image enhancing tools, including Auto Correction plus others, for adjusting attributes such as brightness, sharpness, tone curves, and color saturation, as well as a red-eye removal. It also allows you to adjust, rotate, crop, and print your

Sony's Picture Motion Browser lets you view images and shooting data on your computer monitor. It also offers some basic image-correction features.

JPEG images. It's not compatible with ARW format files, but you can specify that you want to open these files with other software.

Converting RAW/ARW Files

Use the Image Data Converter SR to enhance your ARW format files and convert them to JPEG or to TIFF. This program also includes many tools for adjusting brightness, contrast, hue, white balance, and so on. Experiment with the various tools until you get the color and exposure adjusted to your liking before converting the ARW file. Be aware that extensive adjustment is a slow process, because it takes several seconds for each change to be applied to the image.

A CD comes with your camera that allows you to download Image Data Converter SR. With this program, you can adjust many technical aspects of ARW format files and then save copies in TIFF of JPEG formats.

Take care to avoid loss of important highlight or shadow detail. Set contrast, color saturation, and sharpness at fairly low levels because it's easy to boost these factors using image-processing software after you've converted from ARW; it's much more difficult to moderate or tone down excessively high levels.

After the enhancement is finished, convert and save your image file in an appropriate file folder in your computer. After you click Save As, select the 8-bit option unless you own a program with full support for 16-bit TIFF files. Be sure to give each image a unique name instead of using the more meaningless file name assigned by the camera. Afterwards, you can further fine-tune or manipulate the converted image using your image-processing software.

Some other available image-processing programs include ARW-format converters. These may be faster than Image Data Converter SR as long as they are compatible with the ARW-format files generated by the α100.

Other Browser Programs

Browser programs allow you to look at and organize photos on your computer. They often include additional functions to help you manage your stored image files, such as the ability to search for files, rename photos (either one at a time or in a batch), move image files to different storage locations, resize photos for e-mailing, create simple slideshows, and more.

Picture Motion Browser as a basic browser that can help organize photos. It's not compatible with Mac operating systems, and it is not as versatile as some programs specifically made for this purpose. You can find a number of such browsers for purchase.

For example, the latest version of acdsee software is a superb program with a customizable interface and such features as a calendar that lets you find photos by date. Another very good program with similar capabilities is CompuPic. And Digital PhotoPro was designed by professional photographers and includes some interesting pro features, like a magnifying digital "loupe."

Note: Not many browser programs are compatible with the ARW format and therefore may not allow you to view ARW files. Check the software distributor's website for information about ARW file compatibility with the most recent version of their programs. If you are using Photoshop CS2, Adobe Elements 3.0, or later, with the latest update for Adobe Camera Raw, you will be able to view, open, adjust, and convert ARW files. Some browser programs may allow you to view ARW images, but they cannot convert the RAW data. Do not attempt to open or to modify ARW format files with any software that was not specifically designed for that purpose.

An important function of a superior browser program is its ability to print customized index prints. You can then give a title to each of these index prints, and also list additional information such as your name and address, as well as the photo's file location. The index print serves as a hardcopy that can be used for easy reference (and visual searches). You might want to include an index print with every CD you burn so you can quickly reference what is on the CD and easily find the file you need. A combination of uniquely labeled file folders on your hard drive, a browser program, and index prints will help you to maintain a fast and easy way of finding and sorting images.

Enhancing Your Images

After converting ARW format RAW files, you can use the Sony Picture Motion Browser or another brand of image-processing software. The same applies to any photos that you captured as JPEGs. After you become skilled at working with the basic Sony software, consider upgrading to a full-featured program such as the latest version of Adobe Photoshop, Photoshop Elements, Paint Shop Pro, Microsoft Digital Image Suite, or Ulead PhotoImpact, to name a few.

The Adobe image-processing programs are the most popular among serious photo enthusiasts. If you believe that you'll want a professional version of Adobe Photoshop someday, you may want to start with the latest version of Adobe Photoshop Elements. Many of the tools in this user-friendly program are similar to those you'll find in the more expensive professional version. Elements also has numerous automated (Quick Fix) tools for image enhancement.

Image Cataloging

How do you edit and file your digital images so that they are accessible and easy to use? To start, it helps to create specific folders for groups of images in your computer's hard drive. For example, in "C:MyPictures," you might want to create a variety of folders, titled Vacation 2006, Katie's Graduation, Julie's Birthday 2006, and so on. Create new folders frequently for new events or new subject matter such as Trip to Hawaii or Rob's Florida Birds. You can organize your photo folders alphabetically or by date inside a "parent" folder.

Be sure to edit your photos, keeping those you want to look at more closely while erasing extraneous shots. Before downloading any images, take a few minutes to review them on the camera's LCD monitor. Delete any that are obviously unacceptable. After downloading the remaining photos, check them on your computer monitor; delete those that you don't want in order to avoid squandering precious hard drive space.

Rename the images, selecting more logical file names than those that were assigned by the camera. You'll probably agree that "Julie_BDay_Candles.jpg" makes more sense as a file name than "_DSC4519.jpg," for example. Later, be sure to convert JPEG files to TIFF before enhancing with image-processing software. Processing and resaving JPEG files can cause image degradation.

Hint: After shooting an event, you may want to set up one folder for the images: Bob and Joan's Wedding, for example. After you adjust a photo using image-processing software, save it using a different file name. If the file name was "Bridesmaids_4.tif," for example, you might save the enhanced file as "Bridesmaids_4B.tif." This step will prevent overwriting of the original image so you can later return to it and try entirely different enhancing effects, or use more sophisticated image-processing software.

Create a filing system so you can store and find your photos after you have processed them. One way is to create folders with titles that are meaningful to you, such as "Flor Vaca 200703," to tell yourself this contains pictures from your Florida vacation in March 2007.

Image Storage

Although your images are stored as digital files, they can still be lost or destroyed without proper care. You will need a good back-up system. Many photographers use two hard drives, either adding a second one to the inside of the computer or using an external USB or FireWire drive. This allows you to easily back up photos on the second drive. It is very rare for two drives to fail at once.

However, it is highly recommended that you also burn your images to CDs or DVDs. Hard drives, zip discs, and memory cards are certainly useful devices, but they are not ideal for long-term storage. The life of a hard drive is unknown but hard drive failures can occur after a couple of years, not to mention accidental erasure. And a number of malicious computer viruses can wipe out image files from a hard drive (especially JPEGs).

The answer to these storage problems is optical media. A CD-writer (or "burner") is a necessity for the digital photographer. DVD-writers work extremely well, too, and DVDs can handle about eight times the data that can be saved on a CD. Either option allows you to back up photo files and store images safely.

Hint: For long-term storage of images, only use R discs. The storage medium used for CD-R and DVD-R discs is more stable than rewriteable media such as RWs.

Video Output

The α100 can also be connected to a television set, allowing you to show JPEG images to friends and family in a convenient manner. If you decide to try this feature, start by making sure that the Video output option in Setup Menu 1 is set for the correct TV standard, *NTSC* (North America) or *PAL* (Europe and most other regions of the world).

Turn off the television or the VCR as well as the camera. Insert one end of the video cable (provided with the camera) to the Video Out terminal under the cover for the memory card slot. (It's the same port that's used for USB.) Plug the other end into the video input terminal of the TV or VCR. Turn the video device(s) on and select the video channel. Turn the camera on and press the playback button.

Images will be displayed on the TV instead of the LCD, as they would in conventional camera Playback mode.

Direct Printing

You can also use the α100 for direct printing without using a computer. This feature is available when you connect the camera to a PictBridge compatible photo printer using the USB cable provided with the camera. It works only with JPEG images and only those made in one of the sRGB Color Modes.

Note: PictBridge is a technology that allows for direct printing between a digital camera and printer as long as both are PictBridge compliant. The α100 is PictBridge compatible, as are most Epson, Canon, and HP photo printers released since 2004. Look for the PictBridge logo on the printer's box. Some photo printers also include slots for memory cards, allowing you to print JPEG's directly from the camera's memory card; this method does not require a PictBridge compliant printer.

Start with a fully charged camera battery or use the optional AC Adapter. Make sure that the Transfer Mode option in Setup Menu 1 is set to *PTP*. Turn the camera off and connect the USB cable from the camera to the printer. Then turn the camera on. The PictBridge screen appears on the LCD monitor. Use the Controller keys to scroll and identify the image to be printed and to select the number of copies to be made. You can also activate or close the PictBridge menu using the camera's MENU button.

You can control the entire printing process using the Controller keys to make an index print of all images on the memory card, select the paper size, layout, and print quality, make printer setup changes, and so on.

Direct printing will not give you the same results as printing from images that have been enhanced in a computer using image-processing software because you have far fewer options to adjust such image aspects as color, contrast, brightness, and sharpening. The amount of control you have over the photo is limited entirely by the printer. Some printers do allow minimal image enhancement during direct printing, while others offer none at all.

Digital Print Order Format (DPOF)

Another printing feature of the α100 is DPOF: Digital Print Order Format. This allows you to decide which images to print before you actually do any printing. Then, if you (or your photo lab) have a DPOF compliant printer, it will print those selected images after you make the USB connection. The DPOF options are available in Playback Menu 2 (see page 88).

The DPOF feature is also useful for selecting images on a memory card for printing at a photo lab that uses DPOF compliant equipment. (Ask about that before leaving your memory card.)

Digital Prints

Unless they own a fully equipped darkroom, photographers who still use 35mm must leave their film at a photofinisher for processing and printing. After a period of time passes, they must return to the store to pick up the order.

With digital photography, images can be printed immediately after taking the picture. There are multiple choices for printing. The following are most common:

Computer Download
After downloading images to a computer, use your own photo printer to make prints of any desired image.

Direct-Print Printers
Use a photo printer with a card reader (slots for memory cards) to make prints directly from the JPEGs on your card. Many such machines provide some control over exposure, color rendition, and cropping. Or, hook up your camera to a PictBridge compliant printer to make prints from the memory card in the camera.

Kiosks

Many stores offer self-service photo kiosks. Plug your memory card into the slot. Use the kiosk's controls to crop and enhance JPEG images from your memory card; specify the desired size and quantity.

Photofinishers and Mini-Labs

Most photo labs now have the capability to take your memory card and make prints or CDs from the image files.

On-Line Services

There are many photofinishers that offer their services through websites. Prices are reasonable and your prints are delivered by mail. Once you start an online album on a company's website, you can invite friends and relatives to view images and order prints.

Troubleshooting Guide

The Sony Alpha α100 is a sophisticated camera that provides reliable service. Although rare, a malfunction can occur as with any electronic device. And occasionally an inappropriate camera setting can lead to a technical problem. The following chart provides steps you can take in such cases.

Note: Unlike some cameras, the α100 does not include a reset button for use in case of some electronic malfunction. (The *Reset* item in the menu is strictly for resetting features to the factory-recommended defaults.) However, removing the battery (or unplugging the optional AC adapter) for 30 seconds achieves the same purpose. Do not remove the battery (or disconnect the AC adapter) when the red recording lamp on the camera back is lit; if you do so, the images may be corrupted and, in a worst-case scenario, the memory card may be damaged.

Web Support

Check the Sony Web site (www.sony.com) occasionally for updates to firmware (in-camera software), new tips on problem solving, or information on company authorized service centers in your area. The following recommendations should solve most problems; however, if you experience camera malfunction—especially one that cannot be solved by removing the battery for 30 seconds—contact an authorized service center.

↰ *Sturdy and versatile, the α100 is a great camera to record memories from vacations, trips, and family events. Technical support is offered by Sony through their website.*

Problem	Solution
Cannot install battery	Make sure you are inserting it in the proper orientation
Camera does not turn on	Make sure the battery is charged and properly installed.
Battery life is very short	Ensure that you charge the battery fully as discussed on page 38. If shooting in low temperatures, warm the battery (under your coat or indoors) and try again. In other conditions, gently clean the battery terminals with a soft cloth. If the problem persists, the battery may need to be replaced.
Camera shuts down unexpectedly	See above re: battery. Also remember that the α100 goes into sleep mode after a period of non-use, to conserve battery power. Touch the shutter release button to re-activate it.
Nothing is displayed on the LCD monitor	Press the display button IOI . Make sure nothing is near the camera's eye-piece activating the Eye-Start system; when the latter is active, the LCD display turns off automatically.
The viewfinder image is not sharp	Adjust the eyepiece diopter control to suit your vision.
The camera will not take photos	Make sure the lens is mounted prop-erly. Make sure a memory card is loaded. See if the memory card is full; delete some unwanted images or insert a new card. If using a Memory Stick Duo card, make sure the write-protect switch is set to the Recording (not the Lock) position. Remember too that in some modes, the camera will not fire if the autofocus system is unable to confirm focus, as discussed on page 109. Use manual focus if necessary.

Problem	Solution
The autofocus does not work	Make sure the AF/MF switch is set to AF. If extremely close to your subject, try moving farther. In very dark conditions, the AF system may have difficulty finding focus; try manual focus.
The flash does not work	Make sure the built-in unit is in the up position or that an accessory unit is ON. Flash will not fire in bright conditions in certain operating modes as discussed on pages 157-160; switch to another mode such as P.
Flash photos are too dark	You may be beyond the range of the flash. Move closer and/or set a higher ISO level. If you are not far from the subject, try setting a +1 flash exposure compensation level using the Function dial and Fn button for greater flash intensity.
The bottom of flash photos are dark	In close-focusing, the lens barrel can block some of the light from the built-in flash; move farther from the subject. Try removing the lens hood.
The flash takes a long time to recycle	This is common after shooting several flash photos in sequence.
Blinking numerals (or exposure scale) in viewfinder data panel	The scene may be too dark or too bright for a proper exposure at the selected settings. Try a different f/stop or shutter speed until the blinking stops, set a different ISO level.
Images are too dark	See the item above. Taking photos of a light-toned subject or shooting toward a bright area may require a plus-exposure compensation.
Images are too bright	You may need to use a minus-exposure compensation when taking photos of subjects that are quite dark in tone.

Problem	Solution		
The corners of the image are dark	Remove any filter you have placed on a wide angle lens and replace with a slim-ring filter. Never use more than one filter at a time. (Mild darkening of the corners is common with many zoom lenses but should not be visible if shooting at f/8 or a smaller aperture.)		
The images are not sharp	This is often caused by camera shake or the movement of a subject. Make sure the SSS is on or use a tripod. Set a higher ISO level for a faster shutter speed, particularly if the subject is moving.		
An error message appears when trying to set custom White Balance	De-activate flash. If you do want to set Custom WB for flash, activate flash but move farther away from the white target being used to calibrate the system.		
The camera will not play back images	Make sure the LCD display is on; press the Display button	O	. If the camera is hooked to a computer with a USB cable, disconnect it. If a file folder name has been changed in your computer, images can no longer be displayed on the camera. Also, images made with another camera cannot be displayed.

© Kevin Kopp

Glossary

aberration
An optical flaw in a lens that causes the image to be distorted or unclear.

Adobe Photoshop
Professional-level image-processing software with extremely powerful filter and color-correction tools.

Adobe Photoshop Elements
Elements lacks some of the more sophisticated controls available in Photoshop, but it does have a comprehensive range of image-manipulation options.

AF
See automatic focus.

ambient light
See available light.

anti-aliasing
A technique that reduces or eliminates the jagged appearance of lines or edges in an image.

aperture
The opening in the lens that allows light to enter the camera. Aperture is usually described as an f/number. The higher the f/number, the smaller the aperture; and the lower the f/number, the larger the aperture.

Aperture Priority mode
A type of automatic exposure in which you manually select the aperture and the camera automatically selects the shutter speed.

artifact
Information that is not part of the scene but appears in the image due to technology.

artificial light
Usually refers to any light source that doesn't exist in nature, such as incandescent, fluorescent, and other manufactured lighting.

automatic exposure
When the camera measures light and makes the adjustments necessary to create proper image density on sensitized media.

automatic flash
An electronic flash unit that reads light reflected off a subject (from either a preflash or the actual flash exposure), then shuts itself off as soon as ample light has reached the sensitized medium.

automatic focus
When the camera automatically adjusts the lens elements to sharply render the subject.

available light
The amount of illumination at a given location that applies to natural and artificial light sources but not those supplied specifically for photography. It is also called existing light or ambient light.

backlight
Light that projects toward the camera from behind the subject.

backup
A copy of a file or program. If the original is lost or damaged, the backup is still intact.

barrel distortion
A defect in the lens that makes straight lines curve outward away from the middle of the image.

bit
Binary digit. This is the basic unit of binary computation.

bit depth
The number of bits per pixel that determines the number of colors the image can display. Eight bits per pixel is the minimum requirement for a photo-quality color image.

bracketing
A sequence of pictures taken of the same subject but varying one or more exposure settings, manually or automatically, between each exposure.

brightness
A subjective measure of illumination. See also, luminance.

buffer
Temporarily stores data so that other programs, on the camera or the computer, can continue to run while data is in transition.

built-in flash
A flash that is permanently attached to the camera body.

Bulb
A camera setting that allows the shutter to stay open as long as the shutter release is depressed.

card reader
A device that connects to your computer and enables quick and easy download of images from memory card to computer.

CCD
Charge Coupled Device. This is a common digital camera sensor type that is sensitized by applying an electrical charge to the sensor prior to its exposure to light. It converts light energy into an electrical impulse.

chromatic aberration
Occurs when light rays of different colors are focused on different planes, causing colored halos around objects in the image.

chrominance
A component of an image that expresses the color (hue and saturation) information, as opposed to the luminance (lightness) values.

chrominance noise
A form of artifact that appears as a random scattering of densely packed colored "grain." See also, luminance and noise.

close-up
A general term used to describe an image created by closely focusing on a subject. Often involves the use of special lenses or extension tubes. Also, an automated exposure setting that automatically selects a large aperture (not available with all cameras).

color balance
The average overall color in a reproduced image. How a digital camera interprets the color of light in a scene so that white or neutral gray appear neutral.

color cast
A colored hue over the image often caused by improper lighting or incorrect white balance settings. Can be produced intentionally for creative effect.

color space
A mapped relationship between colors and computer data about the colors.

CompactFlash (CF) card
One of the most widely used removable memory cards.

compression
A method of reducing file size through removal of redundant data, as with the JPEG file format.

contrast
The difference between two or more tones in terms of luminance, density, or darkness.

critical focus
The most sharply focused plane within an image.

cropping
The process of extracting a portion of the image area. If this portion of the image is enlarged, resolution is subsequently lowered.

dedicated flash
An electronic flash unit that talks with the camera, communicating things such as flash illumination, lens focal length, subject distance, and sometimes flash status.

default
Refers to various factory-set attributes or features that can be changed by the user but can, as desired, be reset to the original factory settings.

depth of field
The image space in front of and behind the plane of focus that appears acceptably sharp in the photograph.

digital zoom
The cropping of the image at the sensor to create the effect of a tele-photo zoom lens. The camera interpolates the image to the original resolution. However, the result is not as sharp as an image created with an optical zoom lens because the cropping of the image reduced the available sensor resolution.

diopter
A measurement of the refractive power of a lens. Also, it may be a supplementary lens that is defined by its focal length and power of magnification.

download
The transfer of data from one device to another, such as from camera to computer or computer to printer.

dpi
Dots per inch. Used to define the resolution of a printer, this term refers to the number of dots of ink that a printer can lay down in an inch.

DPOF
Digital Print Order Format. A feature that enables the camera to supply data about the printing of image files and supplementary information contained within them. The printer must be DPOF compatible for the system to operate.

electronic flash
A device with a glass or plastic tube filled with gas that, when electrified, creates an intense flash of light. Also called a strobe. Unlike a flash bulb, it is reusable.

EV
Exposure value. A number that quantifies the amount of light within an scene, allowing you to determine the relative combinations of aperture and shutter speed to accurately reproduce the light levels of that exposure.

EXIF
Exchangeable Image File Format. This format is used for storing an image file's interchange information.

exposure
When light enters the camera and reacts with the sensitized medium. The term can also refer to the amount of light that strikes the light sensitive medium.

exposure meter
See light meter.

extension tube
A hollow metal ring that can be fitted between the camera and lens. It increases the distance between the optical center of the lens and the sensor and decreases the minimum focus distance of the lens.

f/
See f/stop

file format
The form in which digital images are stored and recorded, e.g., JPEG, RAW, TIFF, etc.

filter
Usually a piece of plastic or glass used to control how certain wavelengths of light are recorded. A filter absorbs selected wavelengths, preventing them from reaching the light sensitive medium. Also, software available in image-processing computer programs can produce special filter effects.

FireWire

A high speed data transfer standard that allows outlying accessories to be plugged and unplugged from the computer while it is turned on. Some digital cameras and card readers use FireWire to connect to the computer. FireWire transfers data faster than USB.

firmware

Software that is permanently incorporated into a hardware chip. All computer-based equipment, including digital cameras, use firmware of some kind.

flare

Unwanted light streaks or rings that appear in the viewfinder, on the recorded image, or both. It is caused by extraneous light entering the camera during shooting. Use of a lens hood can often reduce this undesirable effect.

f/number

See f/stop.

focal length

When the lens is focused on infinity, it is the distance from the optical center of the lens to the focal plane.

focal plane

The plane on which a lens forms a sharp image. Also, it may be the film plane or sensor plane.

focus

An optimum sharpness or image clarity that occurs when a lens creates a sharp image by converging light rays to specific points at the focal plane. The word also refers to the act of adjusting the lens to achieve optimal image sharpness.

f/stop

The size of the aperture or diaphragm opening of a lens, also referred to as f/number or stop. The term stands for the ratio of the focal length (f) of the lens to the width of its aperture opening. (f/1.4 = wide opening and f/22 = narrow opening.) Each stop up (lower f/number) doubles the amount of light reaching the sensitized medium. Each stop down (higher f/number) halves the amount of light reaching the sensitized medium.

full-frame

The maximum area covered by the sensitized medium.

full-sized sensor

A sensor in a digital camera that has the same dimensions as a 35mm film frame (24 x 36 mm).

GB

See gigabyte.

gigabyte

Just over one billion bytes.

GN

See guide number.

gray scale

A successive series of tones ranging between black and white, which have no color.

guide number

A number used to quantify the output of a flash unit. It is derived by using this formula: GN = aperture x distance. Guide numbers are expressed for a given ISO film speed in either feet or meters.

hard drive

A contained storage unit made up of magnetically sensitive disks.

high-speed sync

Available only with certain Sony flash units, this feature allows the flash to be synchronized at shutter speeds up to 1/4000 second.

histogram

A graphic representation of image tones.

hot shoe

An electronically connected flash mount on the camera body. It enables direct connection between the camera and an external flash, and synchronizes the shutter release with the firing of the flash.

image-processing program
Software that allows for image alteration and enhancement.

infinity
In photographic terms, the theoretical most distant point of focus.

interpolation
Process used to increase image resolution by creating new pixels based on existing pixels. The software intelligently looks at existing pixels and creates new pixels to fill the gaps and achieve a higher resolution.

IS
Image Stabilization. This is a technology that reduces camera shake and vibration. With most manufacturers, it is usually found in lenses. Sony's Super SteadyShot (SSS) system is inside the camera's body.

ISO
A term for industry standards from the International Organization for Standardization. When an ISO number is applied to film, it indicates the relative light sensitivity of the recording medium. Digital sensors use film ISO equivalents, which are based on enhancing the data stream or boosting the signal.

JPEG
Joint Photographic Experts Group. This is a lossy compression file format that works with any computer and photo software. JPEG examines an image for redundant information and then removes it. At low compression/high quality, the loss of data has a negligible effect on the photo. However, JPEG should not be used as a working format—the file should be reopened and saved in a format such as TIFF, which does not compress the image.

LCD
Liquid Crystal Display, which is a flat screen with two clear polarizing sheets on either side of a liquid crystal solution. When activated by an electric current, the LCD causes the crystals to either pass through or block light in order to create a colored image display.

lens
A piece of optical glass on the front of a camera that has been precisely calibrated to allow focus.

lens hood
Also called a lens shade. This is a short tube that can be attached to the front of a lens to reduce flare. It keeps undesirable light from reaching the front of the lens and also protects the front of the lens.

lens shade
See lens hood.

light meter
A device that measures light levels and calculates the correct aperture and shutter speed.

lithium-ion
A popular battery technology that is not prone to the charge memory effects of nickel-cadmium batteries, or the low temperature performance problems of alkaline batteries.

lossless
Image compression in which no data is lost.

lossy
Image compression in which data is lost and, thereby, image quality is lessened. This means that the greater the compression, the lesser the image quality.

low-pass filter
A filter designed to remove elements of an image that correspond to high-frequency data, such as sharp edges and fine detail, to reduce the effect of moiré. See also, moiré.

luminance
A term used to describe directional brightness. It can also be used as luminance noise, which is a form of noise that appears as a sprinkling of black "grain."

M
See Manual exposure mode.

macro lens
A lens designed to be at top sharpness over a flat field when focused at close distances and reproduction ratios up to 1:1.

Manual mode
A camera operating mode that requires the user to determine and set both the aperture and shutter speed. This is the opposite of automatic exposure.

MB
See megabyte.

megabyte
Just over one million bytes.

megapixel
A million pixels.

memory
The storage capacity of a hard drive or other recording media.

memory card
A solid state removable storage medium that can store still images, moving images, or sound, as well as related file data. There are several different types.

menu
A listing of features, functions, or options displayed on a screen that can be selected and activated by the user.

microdrive
A removable storage medium with moving parts. They are miniature hard drives based on the dimensions of a CompactFlash Type II card. Microdrives are more susceptible to the effects of impact, high altitude, and low temperature than solid-state cards are. See also, memory card.

middle gray
Halfway between black and white, it is an average gray tone with 18% reflectance. See also, gray card.

midtone
The tone that appears as medium brightness, or medium gray tone, in a photographic print.

moiré
Occurs when the subject has more detail than the resolution of the digital camera can capture. Moiré appears as a wavy pattern over the image.

noise
The digital equivalent of grain. It is often caused by a number of different factors, such as a high ISO setting, heat, sensor design, etc. Though usually undesirable, it may be added for creative effect using an image-processing program. See also, chrominance noise and luminance.

normal lens
See standard lens.

overexposed
When too much light is recorded with the image, causing the photo to be too light in tone.

pan
Moving the camera to follow a moving subject. When a slow shutter speed is used, this creates an image in which the subject appears sharp and the background is blurred.

perspective
The effect of the distance between the camera and image elements upon the perceived size of objects in an image. It is also an expression of this three-dimensional relationship in two dimensions.

pincushion distortion
A flaw in a lens that causes straight lines to bend inward toward the middle of an image.

pixel
The base component of a digital image. Every individual pixel can have a distinct color and tone.

plug-in
Third-party software created to augment an existing software program.

polarization

An effect achieved by using a polarizing filter. It minimizes reflections from non-metallic surfaces like water and glass and saturates colors by removing glare. Polarization often makes skies appear bluer at 90 degrees to the sun. The term also applies to the above effects simulated by a polarizing software filter.

pre-flashes

A series of short duration, low intensity flash pulses emitted by a flash unit immediately prior to the shutter opening. These flashes help the TTL light meter assess the reflectivity of the subject. See also, TTL.

Program mode

In this exposure mode, the camera selects a combination of shutter speed and aperture automatically.

RAW

An image file format that has little or no internal processing applied by the camera. It contains 12-bit color information, a wider range of data than 8-bit formats such as JPEG.

RAW+JPEG

An image file format that records two files per capture; one RAW file and one JPEG file.

rear curtain sync

A feature that causes the flash unit to fire just prior to the shutter closing. It is used for creative effect when mixing flash and ambient light.

red-eye reduction

A feature that causes the flash to emit a brief pulse of light just before the main flash fires. This helps to reduce the effect of retinal reflection.

resolution

The amount of data available for an image as applied to image size. It is expressed in pixels or megapixels, or sometimes as lines per inch on a monitor or dots per inch on a printed image.

RGB mode

Red, Green, and Blue. This is the color model most commonly used to display color images on video systems, film recorders, and computer monitors. It displays all visible colors as combinations of red, green, and blue. RGB mode is the most common color mode for viewing and working with digital files onscreen.

saturation

The degree to which a color of fixed tone varies from the neutral, grey tone; low saturation produces pastel shades whereas high saturation gives pure color.

sharp

A term used to describe the quality of an image as clear, crisp, and perfectly focused, as opposed to fuzzy, obscure, or unfocused.

shutter

The apparatus that controls the amount of time during which light is allowed to reach the sensitized medium.

Shutter Priority mode

An automatic exposure mode in which you manually select the shutter speed and the camera automatically selects the aperture.

Single-lens reflex

See SLR.

slow sync

A flash mode in which a slow shutter speed is used with the flash in order to allow low-level ambient light to be recorded by the sensitized medium.

SLR

Single-lens reflex. A camera with a mirror that reflects the image entering the lens through a pentaprism or pentamirror onto the viewfinder screen. When you take the picture, the mirror reflexes out of the way, the focal plane shutter opens, and the image is recorded.

standard lens
Also known as a normal lens, this is a fixed-focal-length lens usually in the range of 45 to 55mm for 35mm format (or the equivalent range for small-format sensors). In contrast to wide-angle or telephoto lenses, a standard lens views a realistically proportionate perspective of a scene.

stop down
To reduce the size of the diaphragm opening by using a higher f/number.

stop up
To increase the size of the diaphragm opening by using a lower f/number.

synchronize
Causing a flash unit to fire simultaneously with the complete opening of the camera's shutter.

telephoto lens
A lens with a long focal length that enlarges the subject and produces a narrower angle of view than you would see with your eyes.

thumbnail
A small representation of an image file used principally for identification purposes.

TIFF
Tagged Image File Format. This popular digital format uses lossless compression.

tripod
A three-legged stand that stabilizes the camera and eliminates camera shake caused by body movement or vibration. Tripods are usually adjustable for height and angle.

TTL
Through-the-Lens, i.e. TTL metering.

USB
Universal Serial Bus. This interface standard allows outlying accessories to be plugged and unplugged from the computer while it is turned on. USB 2.0 enables high-speed data transfer.

vignetting
A reduction in light at the edge of an image due to use of a filter or an inappropriate lens hood for the particular lens.

viewfinder screen
The ground glass surface on which you view your image.

wide-angle lens
A lens that produces a greater angle of view than you would see with your eyes, often causing the image to appear stretched. See also, short lens.

Wi-Fi
Wireless Fidelity, a technology that allows for wireless networking between one Wi-Fi compatible product and another.

zoom lens
A lens that can be adjusted to cover a wide range of focal lengths.

Index

A *(see Aperture Priority mode)*

ADI (Advanced Distance Integration) 83, 85, 153, **156**, 181

AEL 29, 91, **139**

AF-A (Automatic AF) 107, 108, 110, 181

AF area 40, 42, 94, **107**, **110–111**

AF-C (Continuous AF) 107, **109–110**

AF illuminator 93, 107

AF modes 42, **107–110**

AF-S (Single-shot AF) 90, 107, **108**

Aperture Priority mode (A) 36, 122, **123–124**, 158

ARW *(see RAW)*

AUTO mode 36, 75, 84, 85, **120**, 129, 151, **157**, 165

autoexposure lock *(see AEL)*

autofocus modes *(see AF modes)*

bags *(see camera bags)*

batteries 26, 31, 33, **38**, 42, 0, 100, 151, 192, 193, 203, 2007, 208

conserve battery power 27, 38, 43 82, 98, 208

Bayer pattern 46, 47

bounce flash 153, **168**

blur *(see motion blur)*

bracketing

exposure 85, 115, **136–137**

white balance **68**, 115

browser 81, **198**, 199

see also Picture Motion Browser

built-in flash **150–151**, 156, 157, 158, 159, 161, 164, 171

camera bags 49, 50, 152

camera shake 106, 118, 121, 122, 127, 159, 179

camera warnings 19–20, 36, 39, 44, **129**, **139–140**, 142, 158

see also exposure control range warnings

see also Luminance Limit Warning

card reader **192**, 204

Center button (Spot-AF) 29, 36, 38, 79, 86, 88

Center Weighted metering 38, 75, 118, **135**

cleaning

camera 49–50

sensor **48**, **100–101**

close-up photography 125–126, 154, 182

color mode 38, 42, 60, **69–72**, 73, 74, 85, 191, 203

Color Saturation 58, 60, 70, 71, **73**, 120, 191, 195, 197

color space *(see color mode)*

color temperature 22, 23, 33, 57, 61–62, 46, 67, 68, 85

see also white balance

CompactFlash (CF) card 33, 192, 193
compression *(see quality)*
Continuous AF mode *(see AF-C)*
Continuous advance 77, **114**, 121
Contrast 42, 58, 60, 70, 71, 72, **73**,
 120, 191, 197
Controller 29, **36**, 37, 38
Custom Menus 79, **90–94**

data display 40, **41–43**, 94
DEC 70, **72–74**, 120
delete 29, **45**, **86–87**, 99, 200
depth of field 106, 113, 116, 117,
 123–126, 128, 131, 176, 177,
 178, 184
depth of field preview 28, 90,
 125–126
Digital Effects Control *(see DEC)*
diopter adjustment 29, **40**
Direct Manual Focus (DMF) 26, 107,
 110, 181
direct printing 70, 88, 191, **203–204**
download 15, 18, 35, 96, 191,
 192–195, 204
DPOF **88–89**, 194, **204**
D-Range Optimizer (DRO) 26, 31,
 42, **74–75**, 120, 136

effective focal length **47–48**, 103,
 172, 174
electronic flash *(see flash photography)*
erase *(see delete)*

evaluative honeycomb metering *(see
 MultiSegment metering)*
EXIF (Exchangeable Image Format)
 59, 191, 195
exposure bracketing
 (see bracketing, exposure)
exposure compensation 42, 85, 92,
 135, 137, 139, 140, 142, 143, 145,
 147, 166
Exposure control range warnings **129**
Exposure modes 36, 42, 70, 75, 84,
 120–131, 139, **157**
Eye-start 26, 31, 82, 208

file formats **21**, **53–54**, 58
 see also ARW; JPEG; TIFF
fill flash 84–85, 157, 165
filters 22, 23, 65, 68, 210
 graduated neutral density 119,
 129, 130, **186**
 magnifying **183**
 polarizers 73, 156, **186**
 protective **186**
firmware 207
flash compatability 153
flash exposure compensation 38, 39,
 42, 85, 92, 93, 160, **165–166**, 209
flash photography 18, 128, 139,
 149–168, 209
flash synchronization 123, **150**, 153
focal length 48, 124, 126, 152,
 172–177
 see also effective focal length
focus area *(see AF area)*
focus lock 109, 111, 112

focus tracking **109–110**
 see also AF-C
formatting memory cards 17, 45, **87**
Function button 30, **37–38**, 79
Function dial 25, 30, 34, 37–38, 74

guide number (GN) **150**, 154, 167

High Speed Flash Sync (HSS) 39, 150, 164, **166–167**
histogram 19, 25, 36, 44, 135, 139, 140, **142–147**
hue 69, 196
HVL-F36AM accessory flash 153, **154**, 166
HVL-F56AM accessory flash 153, **154**, 166

image processing (computer) 53, 57, 72, 74, 77, 162, 191, 197, 198, **199**, 200
image processing (in-camera) 21, 26, 31, 53, **54–56**, 57, 59, 76
image quality *(see quality)*
image review (instant playback) 41, 43, 44, 80, **82**, 86, 139, 140
 see also Playback Menu
image sharpness **103**, 125, 107
image size *(see resolution)*
instant playback *(see image review)*
inverse square law **149**, 150

ISO 16, **20**, 32, 42, **118–119**, 129, 152

JPEG **21**, **53–55**, 57, 58, 59, 60, 61, 72, 73, 80, 81, 133, 194,196, 200, 203, 205

Kelvin temperature
 (see color temperature)

Landscape mode 36, 69, **71**, **121**
LCD monitor **18**, 25, 29, **31**, **41–45**, **94–95**, 98
lens(es) 13, 26, 31, 48, 49, 83, 90, 103, 105, 124–126, 156, **171–187**
 macro 154, 171, **182–184**
 normal **174**
 telephoto 48, 107, 124, 126, 172–173, **174–177**, 182, 185
 wide-angle 48, 124, 126, 172–173, **177**, 181, 182, 210
 zoom 48, 107, 171, 172, 176, **179–180**, 182, 183, 185
lens hood **187**
lens release button 28
low pass filter 31, 47
Luminance Limit Warning 20, 36, 44, 139, **140**, 143

M *(see Manual mode)*
 with flash 160
Macro mode 36, **121**
Manual (M) mode 36, 75, **130–131**, 139
manual focus 26, 107, 110, **113**, 156, 208
memory card 13, 15, **16–18**, 23, 26, 35, 49, 53, 60–61, 87, 192, 195, 201, 203, 205
 see also Compact Flash (CF) card
Memory Stick 33, 192, 208
metering 15, 32, 38, 83, 112, **115–118**, 132–135
 for flash 153, **155–156**
Mirror up 115
Mode dial 25, 30, **36**, 120
motion blur 121, 127, 128, **162**
MultiSegment metering 38, 85, 112, 118, **132**, 135, 139
multiplication factor
 (see focal length equivalent)

Night View/Portrait mode 36, **71**, **121–122**
noise **20–21**, 76, 103, 118, 142, 152
noise reduction **76–77**, 80, 82

P *(see Program mode)*
Picture Motion Browser 33, 191, 193, 194, **195**, 196, 198, 199
playback *(see image playback)*
Playback menu 44, 45 79, **86–89**

Portrait mode 36, 70, **71**, 84, **120**
power switch 29, **34**
Preflash TTL 83, 153, **156**, 181
Program mode (P) 36, **122**, **158**
program shift 122, 158
protect images **45**, **87–88**

quality 32, 42, 54, **56–60**, 81

RAW **21**, 47, **53–57**, 59, 60, 61, 68, 81, 194, 196–198
RAW & JPEG 21, **57–59**, 81
Rear sync (Flash) mode 159, **162**, 167
Red-eye reduction (Flash) mode **82**, **161–162**
remote operation 34, 115, 163–164, 187
reset 35, **85**, **101**, 207
resolution **21–22**, **54–56**, 80

S *(see Shutter Priority mode)*
Scene Selection modes **120–122**
Self-timer (Shooting) mode **114–115**, 167
sensitivity *(see ISO)*
sensor (CCD) 13, **15**, 21, 31, 32, **46–48**, 54, 61–62, 100–101, 123, 172
Setup menu 79, **95–101**
Sharpness 42, 70, 71, 72, **74**

shutter button 30, 34, 98, 104, 108, 111, 128, 139, 162

Shutter Priority (S) mode 36, 122, **126–128**, **159**, 167

Single-frame advance 69, 85, 113–114, 136

Single-shot AF mode *(see AF-S)*

Slow sync (Flash) mode 122, 123, 139, **163**

Sports Action mode 36, **121**

Spot-AF button *(see Center button)*

Spot metering 39, 40, 91, 118, **133–134**, 139

storage 17, 56, 198, **201–202**

Sunset mode 36, **71**, **121**

Super SteadyShot (SSS) 13, 29, 31, 32, 39, 40, 103, **104–107**, 118, 123, 127, 132, 133, 150, 158, 171, 177, 179, 187, 210

viewfinder 26, 29, 32, **39–40**, 43, 94, 106–107, 108, 109, 111, 113, 125, 132, 158, 160, 209

warnings *(see camera warnings)*

white balance **22–23**, 33, 42, 61–69, 186

white balance bracketing *(see bracketing, white balance)*

zoom head 150, 154 161

zoom lens *(see lenses, zoom)*

TIFF 54, 56, 57, 59, 194, 196, 197, 200

teleconverters **185**

television playback 35, 202

tripods 103, 107, 114, 115, 121, 122, 126, 128, 132, 159, 163, 177, 184, 185, **187–189**, 210

TTL flash metering *(see Preflash TTL)*

USB 29, 33, 35, 38, 96, 192, 193, 195, 201, 202, 203, 204, 210